ANDY WARHOL SERIES AND SINGLES

ANDY WARHOL

SERIES AND SINGLES

WITH ESSAYS BY ERNST BEYELER GEORG FREI PETER GIDAL EDWARD SANDERS

FONDATION **BEYELER**

Contents

Acknowledgements

Our special thanks go to the numerous private and public lenders, as well as those who prefer not to be named. This exhibition would never have been realized without their generous support.

Ludwig Forum für Internationale Kunst, Collection Ludwig, Aachen
Stedelijk Museum Amsterdam
Öffentliche Kunstsammlung Basel, Kunstmuseum
Staatliche Museen zu Berlin, Nationalgalerie, Collection Marx
Irma and Norman Braman
Museum of Contemporary Art – Ludwig Museum, Budapest
Albright-Knox Art Gallery, Buffalo, N.Y.
National Gallery of Australia, Canberra
Museum Ludwig, Cologne
Daros Collection, Switzerland
The Detroit Institute of Arts
Stefan T. Edlis Collection
Museum für Moderne Kunst, Frankfurt a.M.
The Brant Foundation, Greenwich, Conn.
Samuel and Ronnie Heyman
Louisiana Museum of Modern Art, Humlebæk, Denmark
Uli Knecht
Anthony d'Offay Gallery, London
Los Angeles County Museum of Art
Galerie Bernd Klüser, Munich
Solomon R. Guggenheim Museum, New York
The Andy Warhol Foundation for the Visual Arts, Inc., New York
The National Museum of Art, Osaka
The Andy Warhol Museum, Pittsburgh, Penn.
Gunter Sachs
Collection Hauser & Wirth, St. Gallen, Switzerland
Sonnabend Collection
Moderna Museet, Stockholm
Norah and Norman Stone
Collection Froehlich, Stuttgart

Tehran Museum of Contemporary Art, Tehran
Collection Vanhaerents, Torhout, Belgium
GAM – Galleria Civica d'Arte Moderna e Contemporanea, Turin
Hirshhorn Museum and Sculpture Garden, Smithsonian Institution, Washington, D.C.
Thomas Ammann Fine Art AG, Zurich
Galerie Bruno Bischofberger, Zurich
Matthias Brunner, Zurich
Kunsthaus Zürich

We would like to take this opportunity to sincerely thank all of those, without whose effort and dedication the realization of this exhibition and the catalog would not have been possible. Our special thanks go to:

Urs Albrecht, Doris Ammann, Anita Balogh, Heiner Bastian, Dr. Carlo Bilotti, Laura Bloom, Rose Bourgeois, Peter and Stephanie Brant, Maria Brassel, Dr. Markus Brüderlin, Rupert Burgess, Gabriel Catone, Juliana Cavaliero, Martin Cribbs, Gérard Faggionato, Raymond Foye, Vincent Fremont, Ida Gianelli, Esther Grether, Dr. Jacques Kägi, Sally King, Dr. Annette Lagler, Steingrim Laursen, Dr. Rolf Lauter, Massimo Martino, Andrew Masullo, Christa Meienberg, Dr. Eva Meyer-Hermann, Mary Miller, Guita Mirsaeedi, Bob Monk, Tobias Mueller, Claudia Neugebauer, Greg Pierce, Nada Rizzo, Laura Satersmoen, Beth Savage, Dr. Katharina Schmidt, Samir Sibaei, Thomas Sokolowski, Karin Sutter, Krisztina Szipöcs, Jessie Washburne Harris, Dr. Evelyn Weiss, Oliver Wick

We also greatly thank:

Basler Zeitung, Clariant AG, Crossair, MANOR,
Bank Sarasin & Cie, UBS, Die Weltwoche

Introduction

Today, thirteen years after his death, Andy Warhol is more domin-
ant and omnipresent than ever before. His serial works—the
Campbell's Soup Cans, *Disasters*, *Brillo Boxes*, *Jackies*, *Marilyns*,
Flowers, *Portraits*, *Maos*, *Hammer and Sickles*, *Skulls*, *Rorschachs*,
and *Self-Portraits*—seem to have indelibly penetrated our visual
memories and have become a part of how we view the world. No
other artist has had a more profound influence on our perception
and our thinking. As a sort of 'founding father' he not only domi-
nates contemporary painting, photography, video, and computer
art, but also film and fashion—virtually our entire cultural behavior.
Warhol's art always refers to existing material and is in itself a
system of symbols that is easily recognized by every viewer. These
primarily are motifs, born of American consumerism, that have
attained an unparalleled degree of recognition by having been
reproduced millions of times in different media. Their impressive
graphic design is encountered everywhere. In the early 1960s
Warhol was the first representative of the Pop-generation to recog-
nize the hegemony of media language and to artistically use this
language in a series of endless repetitions. The material for his
first pictures (cat. nos. 1–7, 11, 12) was drawn from comic strips
and advertisements that appeared on the backs of tabloids like *The
National Enquirer* and *The Daily News*, as well as from popular
comic books. In contrast to his colleagues Jasper Johns and
Robert Rauschenberg, who had already incorporated similar
examples of 'tale quale' into their paintings of the 1950s, Warhol
isolated and monumentalized his 'ready-made' subjects by pro-

jecting them onto canvas and painting them without preliminary sketches. Trickles and spots of color, as well as networks of decorative, rhythmic lines reflect a dialogue in each work between painting and previously existing material. In *Campbell's Soup Can* (cat. no. 23), *Close Cover Before Striking* (cat. nos. 13, 14), *Do It Yourself* (cat. nos. 15–18), and *Dance Diagram* (cat. nos. 19–21) he completely refrains from spontaneous painterly intervention and, in the spirit of Marcel Duchamp, abandons the role of artist as author by using masking tape, stencils, and rubber stamps. The small format *Campbell's Soup Can* pictures, created at the end of 1961 (cat. no. 23), were Warhol's first attempt at series-painting, that is, using a succession of images based on the same motif in various paintings. Shown at the Ferus Gallery in Los Angeles in the summer of 1962, the 32 nearly-identical soup can paintings were displayed along a shelf, mimicking stereotypical department store-aesthetics. In the large-scale *100 Cans* (cat. no. 28), in which he used photographic material for the first time, and in *Dollar Bills* (cat. no. 26), made by silkscreening one of his own drawings, he experiments with grid-like arrangements of serial compositions within a picture. As in one of Pollock's 'allovers,' the cans and dollar bills spread out over the canvas, seeming almost abstract in their horizontal and vertical system of coordinates. The doyen, Duchamp, had earlier made a reference to the conceptual idea behind this working method: "If you take a Campbell Soup can and repeat it fifty times, you are not interested in the retinal image. What interests you is the concept that wants to put fifty Campbell soup cans on a canvas."[1]

While these first works were, above all else, an attempt to approach the printed material using different stylistic and technical means, they also addressed the idea of a series within a single painting; he perfected this by introducing the photo-silkscreen to his canvases in the summer of 1962. Photo-silkscreening enabled him to use repetitive forms more quickly and effectively in both individual paintings as well as in series. Some of his first photo-silkscreened paintings were the portraits of teenage idols like Elvis Presley, Warren Beatty (cat. no. 32), Natalie Wood, and Troy Donahue. The regular sequence of images in *Troy* (cat. no. 33) is an excellent example of the way Warhol used his silkscreen technique. The black and white images differ from one another only by the halftone in which each was printed, yet the silkscreen in the color portraits serves as a sketch that defines the actual features of the face: it is printed over the hand-painted yellow hair, violet face, and red pull-over. The *Disaster* pictures—quite likely his most impressive and important series—reveal the dark side of American consumer Positivism. The everyday tragedies of automobile accidents (cat. nos. 43–46, 48, 49, 57, 58), suicides (cat. nos. 47, 50, 51, 53), major fires (cat. no. 52), and electric chairs (cat. nos. 54, 56) join together to form an endless series resulting in the death of their original meaning. In many of these paintings, some of which are enormous, the uniformity of the composition is interrupted both by overlapping and smudging the underlying image, evoking a seemingly narrative content and cinematic motion. Yet considered more closely, this 'sensation of time' is just as misleading as in his

first films: it is always the same shot and always the same silk-screened image.

The Factory, which in 1964 became the center for his work, is synonymous with a purely serial method of operation. Yet only the boxes (cat. nos. 65, 66), as they come off the production line, are actually identical to each other. The *Jackie* series (cat. nos. 60, 63, 64), which was also created at this time and uses eight different images of Jacqueline Kennedy taken just before and after the assassination of her husband, and *Flowers* (cat. nos. 59, 61, 71, 77, 79, 81) always do, in fact, show the same motifs, but differ in their arrangement, color and cropping. The four *Marilyn* pictures, which were shot by Dorothy Podber in 1964 and later dubbed the *Shot Marilyns*, are today Warhol Icons. The color of the hair, face and lips are masterfully combined with the black of the silkscreen. Valerie Solanis's attempted murder of Warhol in 1968 led to a turning point in his life and career. By 1972 he was triumphantly back: his consecutive arrangements of the same motif were no longer screened on monochromatic backgrounds, but instead on ones that were more painterly, more abstract-expressionistic. With the exception of *Mao* (cat. nos. 82, 89), which is based on the frontispiece of the "Little Red Book," Warhol not only used mass-produced images of a consumer society, but also delved into different genres of art history. The series of *Hammer and Sickle* paintings (cat. nos. 83–88) are an ever-changing cycle of still-life images in which the objects and their shadows create a fascinating puzzle. The theme of death, which he had already dealt with in his *Death in America*

series, returns again in the 'memento mori' paintings entitled *Shadows* (cat. nos. 93, 96) and *Skulls* (cat. nos. 90, 91). In all of these works a dramatic interplay between painting and the printing process is created, with the expressive background colors seeming to, at times, 'devour' the black and white tones of the silkscreen. In his *Oxidation* series (cat. nos. 92, 97) urination takes the place of painting, referring to Jackson Pollock's bravura painting technique in a sarrastic aside.

The works of the 1980s led to a refinement of his art. *Big Retrospective* (cat. no. 98) alludes again to some of the picture-series that had become famous. *Diamond Dust Shoes* (cat. nos. 94, 95), a motif to which he owed his renown as a commercial artist in the 1950s, and his portraits of artists (cat. nos. 101–103) are transformed magically through the use of diamond dust, while in his last large-scale series, the *Last Supper* (cat. no. 105), he celebrates his own immortality.

Andy Warhol has been represented by three pictures in the collection of the Fondation Beyeler since 1998 (cat. nos. 77, 80, 103), setting a dominant accent in the collection of post-World War II American art. We are pleased to present the work of this most important of American artists in a comprehensive exhibition, with works from important European, American, Japanese, and Australian museums, as well as major national and international private collections. In addition, we believe our new annex open to the public for the first time will prove to be a wonderful setting for the important *Disaster* paintings. The presentation of his serial

production is interspersed and/or augmented in each room by singles from other series, creating an interesting maze of multiplicity and singularity. This rhythmic arrangement corresponds with Warhol's method of production. The early films, which make up an integral part of this exhibition, serve to enhance his paintings and indicate how these two media influenced each other throughout his work. In this catalog the chronological order of the works follows the locations at which they were produced.

Exhibitions always depend upon the willingness of collectors to make their works of art available. Therefore, we would first like to express our special thanks to all the collectors, museums, and others who demonstrated their generosity in agreeing to lend some of their favorite Warhol works to the Fondation Beyeler. We are particularly pleased that with *Troy* (cat. no. 33), *Coca-Cola* (cat. no. 9), and *Suicide (Purple Jumping Man)* (cat. no. 51) we are able to show three works that have not been on public view for over thirty years. Our most heartfelt thanks goes to Doris Ammann, without whose help this exhibition would never have been possible. Special thanks, too, goes to both authors, Peter Gidal and Edward Sanders, whose highly original essays serve to cast a new light on Andy Warhol, an artist about whom there has already been so much discussion. We owe a particular debt of gratitude to the research assistant at the Fondation Beyeler, Delia Ciuha, without whose unflagging dedication this catalog would never have been completed.

Finally, this exhibition is dedicated to the late art dealer and collector Thomas Ammann, who was a close friend of Andy's and a

leading authority on his work. We hope that this exhibition reflects the unique vision of this wonderful man.

Ernst Beyeler Georg Frei

The Fondation Beyeler would like to heartily thank Georg Frei, co-editor of the catalogue raisonné and one of the most inspired experts on Andy Warhol's work, for having helped in the realization of this exhibition through his intensive and untiring work as a guest curator.

Ernst Beyeler

1 Marcel Duchamp, quoted from: Constable, Rosalind: "New York's Avantgarde, And How It Got There," *The Sunday Herald Tribune Magazine* (New York), May 17, 1964. p. 10.

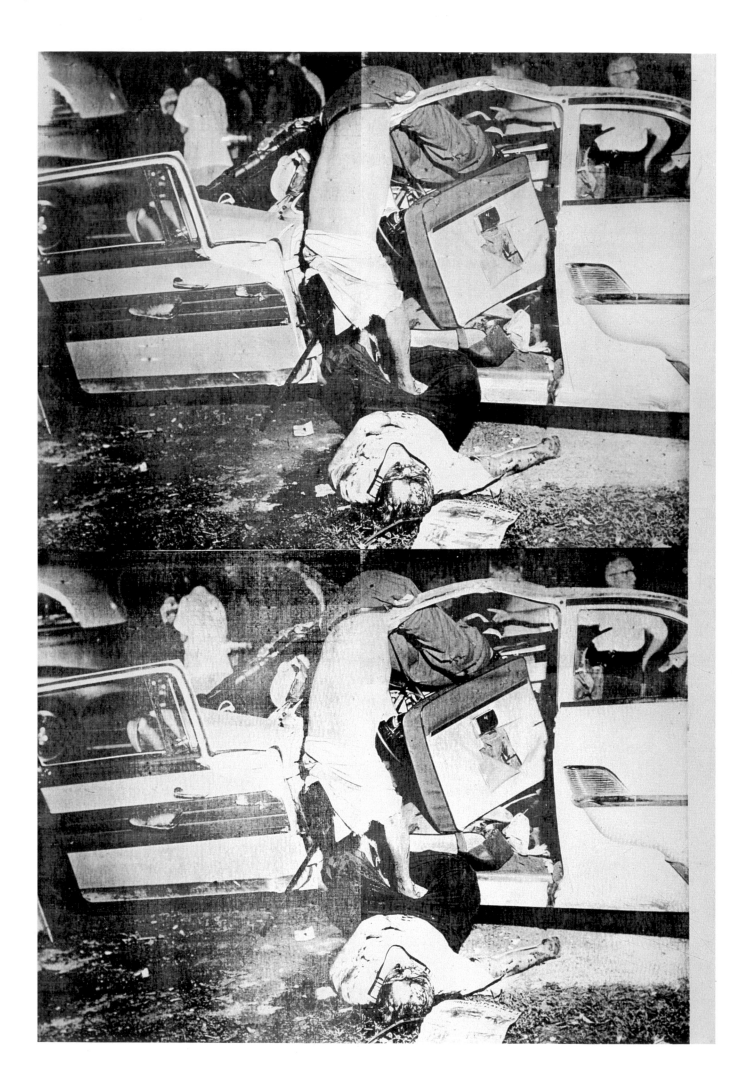

Peter Gidal

Once is never[1]
Warhol's *Saturday Disaster* & *Blowjob*

No two or more substances can have the same attribute.

Spinoza[2]

Warhol's *Saturday Disaster* cannot be perceived when you stand in front of it. The immediacy of an impossibilty—caused by the substance's magnitude i. e. *size* (119 x 82 inches) *not scale*, however screened from consciousness at first moments of perception—forces a mental and physical (i. e. psychosomatic) *attempt to grasp* to be simultaneous to the extraordinary shock of the carcrash/death image(s).

Two images that seem virtually the same in vertical order ineluctably position you in relation to the filmic, that is, to time.[3] Two images wherein our immediate perception is of the *silkscreen hand-touch* (the thinning and thickening of the blacks, greys, whites)—virtually cutting in half the central, and at first view obscure, indecipherable upside-down body halfway across the canvas, an edge resultant from the ending of one ink-application, the beginning of another—equalled by our perception of an image as *mechanical reproduction* (its newspaper-likeness, its *Weegee/Daily News* signification), mass reproduction of the means of production of death, and—again—the cutting in half of the central upside down body where one screen 'ends.' It's being neither the one nor the other.

The illusion of movement in *Saturday Disaster*, the illusion of stillness in the film *Blowjob*; the illusion of stillness in *Saturday Disaster*, the illusion of movement in *Blowjob*.

Andy Warhol
Saturday Disaster
1963
118 7/8 x 81 7/8 inches
302 x 208 cm
Rose Art Museum, Brandeis University,
Waltham, Massachusetts.
Gervitz-Mnuchin Purchase Fund

As to the painting: this illusion of movement brings to consciousness the thought of a moment after (not necessarily beyond) death. Attempting to grasp that painting's imagery, straining to look up at the top 'half,' you are (due to one panel being five feet high, i.e. human scale, two panels stacked vertically anything but) *faced* with the bottom panel first, in terms of recognition of what it represents, people, cars, an event, a moment after an accident, etc., the moment after (but not beyond) death.

Having initially, momentarily, strained to look up at the top 'half,' what is then faced at human scale, the lower panel, is already a repeat in static form of something preceded and lost, already each time a memory, a memory preceding the living act of perception of the as yet new, this auratic shock of living death's mimesis. *"The memory of a moment is not informed by everything that has happened since; the moment which it has recorded still endures, still lives, and with it the being whose form is outlined in it. And moreover, this disintegration does not only make the dead one live, it multiplies him or her. To be consoled I would have to forget not one but innumerable Albertines. When I had succeeded in bearing the grief of losing this Albertine, I must begin again with another, with a hundred others."* Marcel Proust[4]

When you again look up ten feet to re-see the 'same,' the bottom panel retroactively enacts itself as follow-on; it is in that sense 'filmic.'

The confusion for you is is it 'simply' double; is that more, somehow? Is it a doubling, deadening reification, thereby 'less'? Or

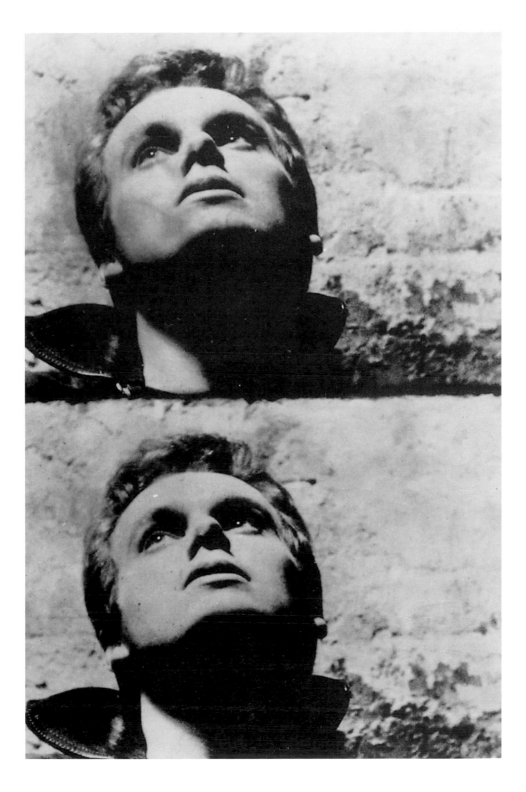

Andy Warhol
Blowjob
1964
16mm film,
black and white
(30 minutes)

is it neither, i.e. not the top panel somehow different from the bottom panel, but the same? The same, something twice, is impossible, producing unease. What is to be disinterred is whether time's stoppage or time's persistence is death; in time's stoppage the moment of presence becomes timeless existence, but rather than transcending death thereby, Warhol makes the image precisely one of death, conferring a terrifyingly anxious, irresolute, contradiction.

The disturbance when the image of death overwhelms you is here inseparable from the inability to define it.

In the end it is time's *passage* presaging repetition—the temporal of Warhol's process—that makes such a painting so powerful. The repetition (with whatever imagistic differences caused) being the inability of escape. Lost in that, offered no definition either that would then result in a viewing coming to an end, a viewer finding substance, it or we thereby defined as finally being 'about' something, however complex. We are not given the wherewithal of its inhering ideologies to place it. Instead, we are left with time's persistence, the image sequence.

In unlikeness to contemporary culture, the wherewithal to deal with the work is not given by the work, it is in that sense alienated from its cultural context, however blatantly at first this seems with Warhol's work not to be the case.

Saturday Disaster has—as has death—no place. *You* have to pull yourself away from *it*, powerless, rather than having been enabled to place it within a realm of meaning or the senses that would befit. Here illusion of movement and illusion of stillness[5] are never

without the *simultaneity* of: the atemporal presence of *substance*; the temporal[6] presence of *being* (i. e. spatially represented[7] objects and people); and *time*, endlessly irretrievable from the viewer's temporally specific, historical present.

Not making of Warhol's realities of painting a repetition of something *else*, *Saturday Disaster's* singularity is in confronting death's irreducibility, its nonrepresentability in representation. This is not negation, it is deeper and more radical than that. It is painting about what painting cannot be.

In the thirty-minute film—content self-explanatory—*Blowjob*,[8] in the end and in the beginning, movement over stillness—however slight the (camera) movement, however slight the subject's stillness—is preceded and followed by film flare-out's *material* flickering and fogging. Flare-out, lasting perhaps six or seven seconds, wherein light enters, unequally, the edges of the 16mm filmreels as they're being loaded into the camera, produces effects of partially whited out imagery whereas what the camera+lense is aimed at produces the photochemical imprint necessary for photomechanical reproduction. Flare-out: extremes of white and shade, and light and its absence, upon and through whatever image is at that moment represented; these material (quantitative) effects surpass any (Wölfflinian) form or (post-Freudian / Lacanian) *to-be-analysed* contents—thwarting analysis equally of the possible Gnostic epistemology white / dark.[9]

What remains? Presence and its filmic problematics. *Object.* Entropic stillness is how distinguished from essence or transcen-

dence regardless of form? By *object* being the film and the filmed, not an existential cool or hot of a distanced-or-not phenomenal object. Thus one of the concrete effects—theoretical and practical—in the real world of this work was to make the category viewer/view*ing* inseparable. Film as projected rather than film as deconstructed. The processing of such ideologies. Conventional cinema has instanciated the viewer as voyeur, within which's definition the act of viewing is disavowed. Warhol is, in this work, radically anti-voyeurist.

The radicality of that, against identification in its unconscious manifestations, against fetishization (even, importantly, of filmic process) produced in *Blowjob* representation's inadequate[10] power over the machine's durable—and unendurable—time.

Words can dissolve[11]—film, Warhol's *Blowjob*, can—a viewing apprehending as endless endless time endlessly ended. That endless presence is its history—*Geschichtlichkeit*—each moment of *stare* the death of each prior and future moment. This presence of time and its simultaneous absence is the persistence, not of vision, but of nothing, a state of nothing neither 'to be reached' via the transcending of other states, nor, turned upside-down, made into a positivity ('the opposite of something'), but a machined unstoppable presence—the I at odds.

Repetition's effect of near-stasis—stilling—paradoxically belies its vacuity as pneuma for our knowledge and belief, power and control. Said differently, the film as embodied trace of use, and exchange, value is denied. The filming is in obscure relation to the

body: it is precisely the *intervening* spectator's speechlessness[12] that constitutes the radical dialectical moment—identities no less in crisis than identifications, voyeurism without spectacle—of which Warhol's *Blowjob* a precurser, *accursed progenitor*![13]

1 Walter Benjamin, Theodor Adorno: *The Complete Correspondence 1928–1940*, Polity Press/ Blackwells/ Harvard, 1999.

2 Spinoza: *Ethics*, Prop. VIII, *Proof*, p. 4, London: J.M. Dent, 1986. Defining substance itself doesn't begin to answer how an *aesthetic* moment is to be articulated against any other. So one begins with perception and conception in utter unavailability of anything else.

3 Time as distinguished from duration. "When you say time you're floundering, when you say duration I understand it." In: "Hollis Frampton / Peter Gidal, an Interview (1971)," *October* (New York), no. 32, Spring, 1985. In fact it is precisely time, not duration, that must be meant because duration is now understood as moving filmically from point a to point b (and back again?) whereas time as a concept and as a concretion doesn't allow for a rational measure of beginning and end, though producing temporality; it is this conception of time which Spinoza, to confuse matters, calls duration, in terms replete with echoes of Gertrude Stein: *"Duration is indefinite continuation of existing."* *Ethics*, p. 38. And further: *"We attribute to the human mind no duration which can be defined by time, save in so far as it expressed the actual essence of the human body, which is explained by means of duration and is defined by time, that is we do not attribute duration save as long as the body lasts."* p. 214. What this gets at (I think) is the usage of duration (*"conceiving of things"*) as eternal (*"wanting* [in absence of/the author] *beginning and end"*) and time (*"power of determining the existence of things"*) as measurable instance of the present. It is in that sense that it must be seen here; Warhol's filmic durable and unendurable temporality surfaces as much in *Saturday Disaster* as in *Blowjob*.

Warhol's extreme in relation to death and time, the 100 minute film *Henry*, through each re-screening disables again (and again) cursory assumptions both of "death (being) dead when time is dead" (Beckett on Proust) and of presence either by definition in time or by definition eternal each time again.

4 Proust, Marcel: The Captive and the Fugitive (in *Search of Lost Time*, vol. 5). Transl. by C.K. Scott Moncrieff and T. Kilmartin. New York: Modern Library, 1993, p. 487. (Translation partially revised by the author.)

5 With materialist film, film that does not suppress its (illimitable) processes—Warhol's particularly, *Blowjob* an instance—the *illusion of stillness*, the visibly projected sixteen frames per second passage of acetate, is perceived because the subject is so still and the (other) material projected—acetate—is not (scratches, flare, dust, refraction, etc....). Betraying, minutely, unstoppable machine-movement.

6 For the possibilities of painting that doesn't suppress its (illimitable) processes—in Therese Oulton's *Static*—the temporal is produced (and perceived as such) through the continuum of samenesses because each of the 'film-frames' is held to its painted state—states of (repeated) stasis. When the eye descends or ascends due to light *between* frames taking attention up or down, such stasis is opposed by a viewer-become-movement. The simultaneity of states produces a temporal stasis as illusionary as its momentary relinquishing. The disturbance for viewing is the disturbance of this conceptual contradiction: continuum of samenesses. Betraying, minutely, unstoppable *painting*.

More particularly, *Static's* 'off-screen' grey-white impinging from the left into each respective filmframe partially obliterates and *makes tense* each left frame edge. It makes vertiginous a knowing of—and relation to—*Static's* substance: is it one painting conceptually whilst a series of paintings perceptually? *No substance in so far as it is substance, can be divided into parts.* (Spinoza). Your look is down the painting (frame by frame—within which endless fractal optics—as opposed to an occular sweeping-across) whilst attempting to see 'a' painting. Escaping thus neither into form nor into a metaphysics of process, each separate and particular contingency is given—painted—as that, the ineluctable temporal.

7 How can a spatial opposite in every determination produce the so same. (The concept—the aesthetic dynamic—of the different and the same disallows philosophical interrogation its recent sejour.) With Gerhard Richter's *Gehöft* size not scale is the immediate radicality: 46 x 51 cm/18 x 20 inches. Its unlocalizability of 'content' attaches thereto: each segment of & in the painting making more impossible the necessary spatialities—and consequent congruences—of place. This shock of small still-life size—as was against all expectations the first perceiving of Malevich's white on white—makes you look 'into' what is 'out there.' When this into is of an out-there as with *Gehöft*, the *Unheimlichkeit* (strictly: out of home, secreted) is of the physical *turned*

Therese Oulton
Static
1999
65 3/4 x 57 3/4 inches
167 x 146.7 cm

inside out; you paint the inside of a skull by painting the outside of a skull (mental consequences elsewhere). Apart from *Gehöft's* concrete photo-image at first instance being inapprehendable as to 'right side up,' the further *immediate* inapprehendability is of e.g. the top right rectangle ('background') of the picture disallowing the real its depths. Spatial irrelations—of whatever still life is here in the end perceived—are determinately not a fall into abstraction.

Unbounded by either definition abstract or nonabstract, *the scale so condenses either reality at the moment of each's perceived inception.* Either reality is repeatedly over-painted; the canvas an over-painted fourth wall, leaving literally no three dimensional projection for you to be 'in.' „Man versucht der konkret sich forcierenden Abstraktheit zu entgehen, es ist nicht möglich, man versucht MIT der Abstraktion, oder dem Abstrakten, eine Logik oder einen Glauben oder eine Sicherheit des Sehens zu ‚gewinnen' und das ist genau gleich unmöglich, denn das Reale schiebt sich sozusagen davor, an die Fläche des Bildes aber auch als eine flache Konstruktion als Mauer gegen Perspektive und ‚Wahrheit' oder ‚Schönheit' oder ‚Authentizität.'" (Peter Gidal, letter to Gerhard Richter, 25 May 2000). Richter refuses—to what in his paintings, if not in the real world, are *made* the noncompliant representational 'elements'—recognition, let alone integration as elements. *That whose knowledge does not depend on knowledge of any other thing… each attribute is conceived through itself without the aid of another.* (Spinoza, ibid, pp. 5 & 41) So the picture becomes a disturbance for viewing: to make a painting that presents itself as no more a solution as to how than as a solution as to how not to represent. Painted, as that—the ineluctable spatial.

8 *Blowjob's* 30 minutes are made up of 100 foot, 2 3/4 minute 16mm filmreels. Writing this has a pleasure in that it was the first Warhol film seen by me, someone at the film society at Brandeis University showed it (on February 11, 1965 according to Callie Angell, currently finishing the Warhol film raisonné) along with some long-forgotten feature; radically shocking as it seemed on one level of the temporal, still, entropic, yet befitting an ideology of the poetics of Hölderlin and Trakl, Rimbaud and Genet, for someone who had "recently come down from the Zugerberg [near Zürich], an isolated mountain in Switzerland with a school, some farmers, trees, cows, and Alpine flowers, it was a beautiful and fascinating film…" (Peter Gidal: *Andy Warhol, Film and Paintings*. Studio Vista/Dutton, 1971, reprint with introduction, N.Y.: DaCapo Press, 1991, p. VI). Writing this has a pleasure too in that the first Warhol painting seen by me was *Saturday Disaster*, at the Rose Art Museum at Brandeis, fifty meters from my hall of residence, viewed with a sense of strangeness over and over in 1965…

Gerhard Richter
Gehöft
1999
18 x 20 inches
46 x 51 cm

9 Can a representation be a representation without being a *representation-of*? This problematic attached itself in analysis of Warhol's *Hammer and Sickle* paintings wherein the question is of a shadow being a shadow *of*, as much as in the shadow paintings themselves. See Peter Gidal: "Some Problems 'relating to' Warhol's *Still Life* (1976)", *Artforum*, May, 1978. Contiguously see also "the eradication of representation as much by light as by dark" in London Film Co-op Catalogue 1974, Notes on Peter Gidal's *Room Film 1973* (1973).

10 'Inadequacy' meant as the production of aesthetic effects of non-adequacy, not as a moral normative category of some lack or other.

11 E.g. in Gertrude Stein's *Tender Buttons: Rooms/Objects/Food* (1913). Words' meanings dissolving through mental intractability. Kafka's *Betrachtung* (1913): words' meanings dissolving through their physical intractability aligned to their very mental tractableness. The linguistic dissolutions caused by the large 16 pt. letterpress text in and literally *on* the pages of *The Lost Ones* has the 22 pt. letterpress of the original edition of *Betrachtung* as precedent.

12 Adorno strangely seems to posit an empirical spectator when theorizing the concept of (theatrical) intervention, opposing to this a posited interventionlessness of the speechlessness of silent film."Kafka's novels are not screenplays for experimental theatre, since they lack in principle the very spectator who might intervene in such experiments. They represent rather the last and disappearing connecting texts of the silent film… the ambiguity of gesture… sinking into speechlessness…." Theodor Adorno, letter to Walter Benjamin, 1934, ibid.

13 Hamm to Nagg, in: Samuel Beckett: *Endgame*.

Edward Sanders

Andy Warhol and the Glyph

It showed how serious Andy Warhol was, when he first came to New York City in '49 at the age of 21, that he stopped several times a week in a church to pray for success in the art world. His devout mother Julia, who later followed him to NYC from Pittsburgh, also prayed for his victory. At first he realized his prayers as a success-ful fashion illustrator, but all the while he was thirsting, striving, hungering, and planning for Total Fame. "I want to be Matisse," he said in 1956. His success as a fashion illustrator came in good part from his skill at giving power to images. He was adroit at supercharging a fashion design—a skill which he put to historic use a few years later in the new-fangled form known as Pop Art.

The Scene—Chasing the White Stag of Fame

Warhol brought a very high metabolism to the already highly meta-bolic NY art world. They called it "the Scene" during those years. The scene included the galleries, the museums, the hip nightclubs, the Happening movement, performance spaces for jazz, avant-garde rock & roll and modern dance; the poetry coffee houses, the East Village, the West Village, the Upper East Side, and the burgeoning world of the loft. In certain ways it was classless—the rich and not-so-rich could commingle and share the energy of the Scene, and cross-class pollination was not such a big deal. He was brilliant at analyzing how to spend his time in the chaos of the late 1950s and early '60s, when the tone of America changed from Eisenhower to Kennedy. Warhol became the ultimate nighttime pacer in New York City. He was everywhere, absorbing all aspects

of the Scene. So startling was his influence, that the entire NY scene became a kind of Warhol Zone. In that Zone, Warhol, the poet Allen Ginsberg and a core of others were the Symbols of the New. They were always there, always active, and there was a feeling that things were going to change drastically, maybe even for the better.

During those years our paths crisscrossed fairly often. I first met him in 1963 at a showing of Underground films. The museum curator Henry Geldzahler introduced us. Warhol was known in the poetry community then for his generosity. He gave the poet Ted Berrigan, never very flush with cash, one of his *Brillo Boxes*. For the opening of my Peace Eye Bookstore in the Lower East Side, Warhol made a few silkscreened cloth banners of his famous *Flowers* image. He created, on an early photocopy device called the Thermofax, a cover for my poetry publication, *Fuck You/A Magazine of the Arts*. He came to a number of performances by my band, The Fugs. Once at a Fugs performance called "The Night of Napalm" we tossed a basket of spaghetti with marinara sauce out into the audience, glops of it smunching into Andy along the front row.

Energy as Eternal Delight

How did he create day and night in those years amidst the chaos & swirls? Partly it was youthful frenzy, and partly it was from being alive in the Age of Uppers. Whereas the early 21st Century may be the Age of the Calmdown—featuring pills with strange names like

Paxil, Zoloft and Prozac—the early years of the Warhol Zone, say 1961–68, were those of the upper. Allen Ginsberg had written much of his great poem *Kaddish* on uppers; Jack Kerouac once wrote an entire novel, *The Subterraneans*, in a single weekend on uppers.

As William Blake once wrote, "Energy is Eternal Delight." At his best, Warhol had a kind of playful Energy, in the spirit of *homo ludens*, humankind at play or at sport, in a kind of agitated peace. And it was that Energy, much of it playful—the energy of *homo ludens*, the concept of man at play, that emanated during those years from the Warhol Zone. Another source of the energy was his custom, established early in his career, of surrounding himself with acquaintances and "stars" known for their loquacious anxiety. Inside that anxiety Warhol calmly created. Controversy also, in a strange way, helped his creativity. Though he was always surrounded by it and always said "Hi!" to it, he learned one great thing about controversy—while it swirls around you, make sure you keep at your art day and night. The R. Crumb motto, "Keep on Truckin'," was translated to the Warhol Zone as "Keep on Screenin'."

A Way with Words & a Way with Images
When he arrived in New York City after graduating from college, he had not yet honed his famous skills in colloquy. In fact he was somewhat fumbly-mouthed, his speech patterns sometimes ungrammatical, and featuring the accent of someone who had grown up in a household where English was not the first language. Just as

he developed an uncanny sense of the apt image, he learned how to fashion quick one-liners which were quoted around the world. They were a useful tool with which he could defuse his detractors with apothegms and pithy, semi-philosophical sentences.

Warhol encountered the first buzz of Total Fame around 1962. Initially it was the kind of fame he couldn't be sure was really fame. Some of the attention was what they call "negative" and what Chekhov, after the tumultuous opening night of *Ivanov* in 1887, called "applausamento-hissing." In America, however, negative ink can provide the backdrop for triumph. Andy was already in New York when *Time* magazine derided Jackson Pollock as "Jack the Dripper."

Silkscreen '62

By the early 1960s he had had a number of exhibitions and he was known as a skilled draughtsman. In the summer of 1962 he began experimenting with silkscreening images onto painted canvas. The results were startling images that were to place him at the forefront of modern art. The spirit of the aleatory, that is, of John Cage's chance operations, came into play in these early silkscreens, when talent overwhelmed technique. I was friends at the time with Warhol's assistant, the poet Gerard Malanga, who told me about some of the casual and accidental silkscreen results.

Andy had a showing of his hand-painted *Campbell's Soup* works in Los Angeles that July, and then, just as it closed, Marilyn Monroe's housekeeper on August 5 found her dead at 36, a

sleeping pill vial beside her. Marilyn appealed to a vast variety of Americans, from beatnik loners to people of power. President Kennedy was very likely one of her lovers. J. Edgar Hoover, head of the Federal Bureau of Investigation, had a nude photo of Monroe in his basement rec room in Washington, D.C.

Andy Warhol acquired a still from her torrid 1953 film *Niagara* and began a series of 23 paintings utilizing his new form combining painting and screening.

A Muse for Warhol's Artistry

The English poet Basil Bunting once described poetry to Ezra Pound this way: "dichtung = condensare." The equivalent of that condensation in art is to be found in our time in what could be termed the Retained Image—in work inspired by a new muse or creative force. That force I call Retentia, the muse of the Retained Image. Retentia helps the artist freeze or seize the apt image from the overwhelming plethora of possibilities in our very image-retentive time. She's a muse for the age of the microdot, the digital still, the scan, the collage, the photo and the movie. From the moment he began screening that still from *Niagara,* till the end of his life, Andy Warhol made great use of Retentia's skills.

Thus, when the young Warhol said "I want to be Matisse," it was more than just a whimsical sentence. For the great Matisse himself became a partisan of Retentia when, toward the end of his life and he could no longer paint, he created with his scissors those beautiful gouache cut-outs, which, with the help of an assistant, he

arranged from his wheel chair onto the wall—some of the finest art of the 20th century. Mr. Matisse would stare at an object, waiting to catch its "sign," its essence, before he would scissor its shape. "You have to study an object a long time to know what its sign is," he once said.

He was being helped by Retentia.

The Rise of the Glyph

The startling images that Warhol began to create of Elvis Presley, Marilyn Monroe, Elizabeth Taylor and others, bore some resemblance to what in Egyptian hieroglyphics were called Determinatives— that is, ideograms which define the sense of a word or the meaning of a word. The Egyptians believed the hieroglyphs in a temple took on a life of their own. And so, in a way, Warhol was putting to marvelous use an ancient art form, the Glyph. One of the high points of his art was his hieroglyphizing of the human face—*Elvis*, *Marilyn*, *Mao*, *Liz*, *Jackie* among them. They all seem "alive" in some special glyphic universe.

Marilyn as Glyph

Warhol's image of Marilyn Monroe could be interpreted as a Determinative for an ancient word. That is, if Andy Warhol had been an Egyptian scribe in 2300 BC, he might have painted the hieroglyphic word for Marilyn this way:

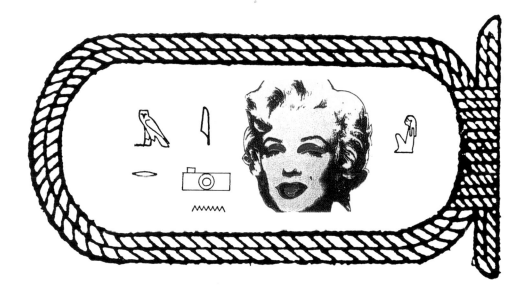

Following History with Andy's Glyphs

In a way you can follow some of the history of the era through Andy Warhol's images. Those early years in his career when he discovered screening (and filmmaking) saw ghastly upheavals in the USA, especially in 1963, a year which Andy met with some of his finest work. Shocking images were everywhere. The Cuban Missile Crisis, which threatened a worldwide nuclear disaster, was just a few months in the past. There was the beginning of the great national debate over Vietnam, and the horrific photo in the media, for instance, of a Buddhist priest burning himself to death on a street in Saigon. In Birmingham, Alabama, in 1963 the Reverend Martin Luther King Jr. was leading demonstrations. Birmingham

was a totally segregated city and had closed its playgrounds, golf courses and swimming pools rather than integrate them. Birmingham shocked the world with television footage of police attacking demonstrators with biting dogs and high-pressure fire hoses. Warhol captured a sense of the horror with works such as his *Red Race Riot*.

Some of my favorite Warhol silkscreen paintings were those of Elizabeth Taylor done in 1963. It was the year of *Cleopatra*, starring her and Richard Burton. Warhol reached back to a still from the 1960 movie *Butterfield 8*, an image he transformed into a great silkscreen/painted Glyph. It was in her lips—erotic, mystical, semi-smiling—that I think he captured the very essence of Ms. Taylor. Andy's *Liz* reminded me somehow of the goddess Isis.

A Silver Factory

In the beginning of 1964 he moved into his famous "Factory" at 231 East 47th, not far from the United Nations building. Two months before, November 22, 1963, saw the evil assassination of a President, and the public dignity, almost like that of the grieving goddess Demeter, shown by Jacqueline Kennedy. Warhol captured Jackie in a series of remarkable paintings, including the large work *The Week That Was* in which he utilized images of her from newspapers.

By 1964 Warhol had begun to making startling and controversial movies, but his explorations into the nature of the Retained

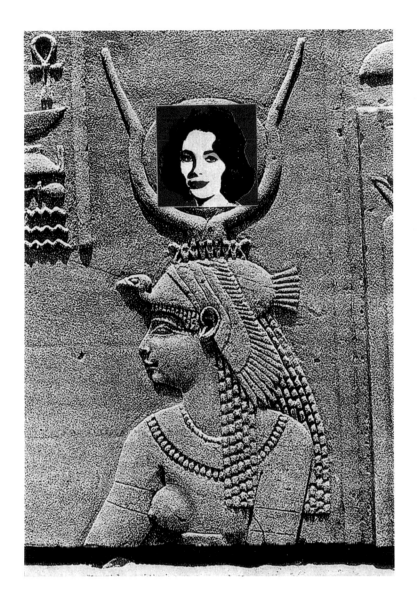

Image continued. He had completed work on the first *Electric Chair* paintings and 20 images of a young woman spread on the dented roof of an auto, who had leaped off the Empire State building, a work called *White*. In January the two-panel *Blue Electric Chair*, for instance, was exhibited in France to great acclaim.

While the Factory was being covered in aluminum foil, from January to April, '64, he started working on the painted wood *Brillo Boxes*, an act of creativity razor-sharp in its controversy. The New York World's Fair opened in the summer of 1964. Andy had been commissioned to do a mural for the American pavilion. So he prepared a 20 foot by 20 foot work in black and white called *The Thirteen Most Wanted Men* which featured the police mug shots of criminals. It was installed, along with works by Robert Rauschenberg, Roy Lichtenstein, and others. The Governor of New York, Nelson A. Rockefeller, was displeased with the work, and ordered it removed. Rockefeller already was famous for such things—he had ordered a famous Diego Rivera mural in Rockefeller Center painted over during the 1930s, and during World War II Rockefeller had censored a government-sponsored movie by Orson Welles.

Warhol was instructed to remove or replace *Wanted Men* within 24 hours. When they would not accept his idea for a substitution (a painting with panels of a public official named Robert Moses) Andy went out to the World's Fair pavilion and had the work painted over in silver.

Then Flowers

Also going out to the World's Fair with Andy that April day in '64 was his friend Henry Geldzahler, who suggested that Andy give up the *Death and Disaster* series he had been painting for a number of months. To show what he meant, Geldzahler pointed to some flowers in a magazine. The result was the great series of poppy flowers, truly Glyphs of joy, based on a photo from *Modern Photography* magazine. The *Flowers* were wildly successful and predicted the American Flower Power movement three years ahead of its time.

Legacy of the Retained Image

For the next 23 years Warhol continued in an almost nonstop surge of art till his passing in 1987. The rest of his life was built upon those years of finding the Glyph, say '62–'64. His startling images continued without cease—*Mao*, *Joseph Beuys*, many friends, his *Diamond Dust Shoes*, and his giant version of Leonardo's *Last Supper*. Though his legacy was complicated, his politics often were fair, and there was a radical/conservative coupling in his art that reminds me of certain writers who have offered us mixed messages—Dostoevsky and Kerouac come to mind. It is in his Glyphs that he will last.

Plates

1344

44

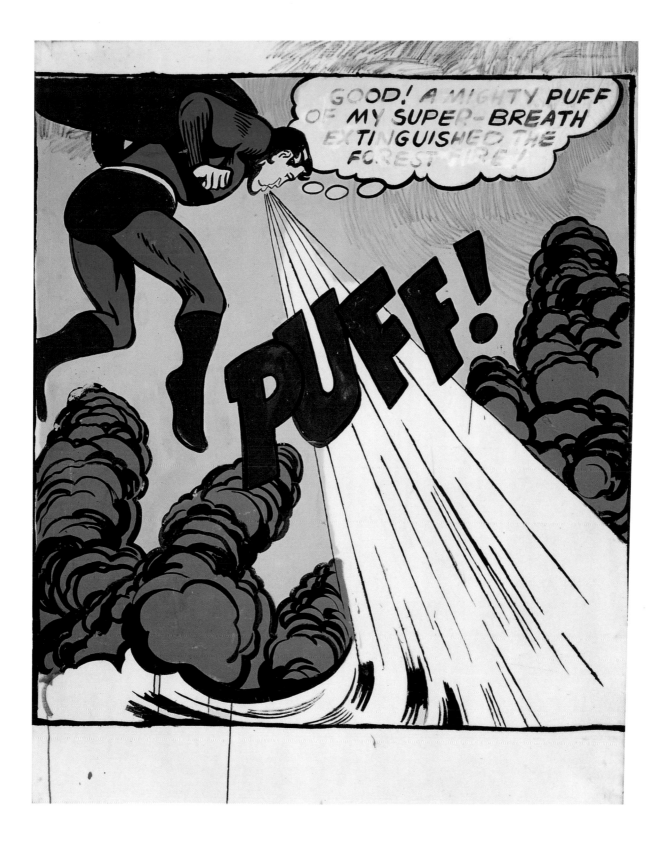

1 **Superman** 1961 Collection Gunter Sachs

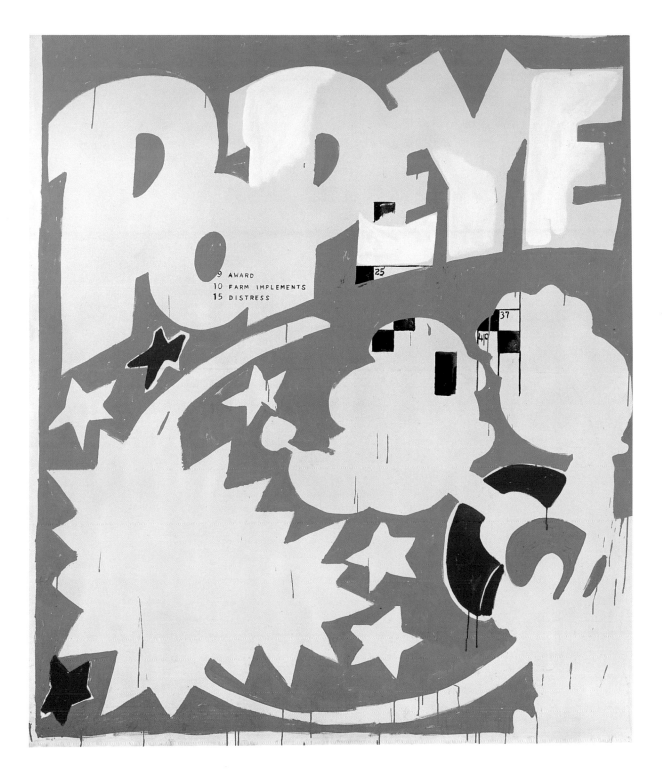

2 Popeye 1961 Private collection

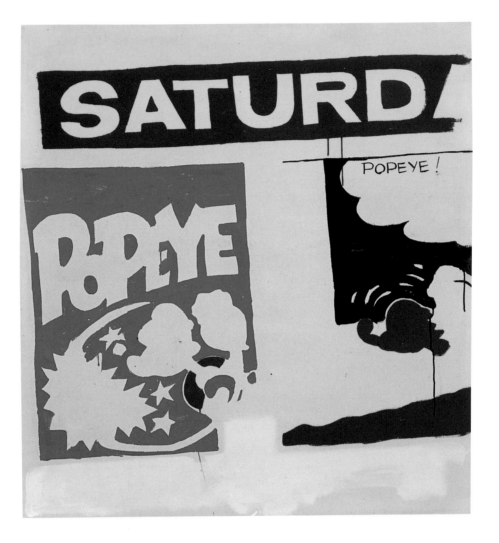

3 **Saturday's Popeye** **1961** Ludwig Forum für Internationale Kunst, Collection Ludwig

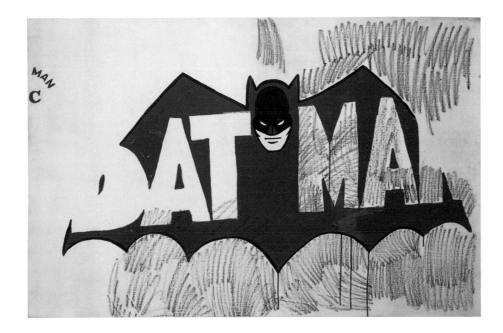

4 **Batman** **1961** Private collection

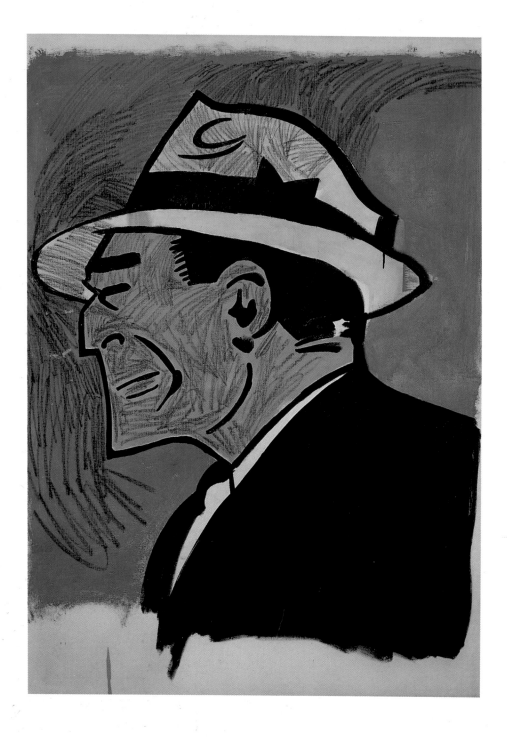

5 **Dick Tracy** **1961** Courtesy The Brant Foundation, Greenwich, CT

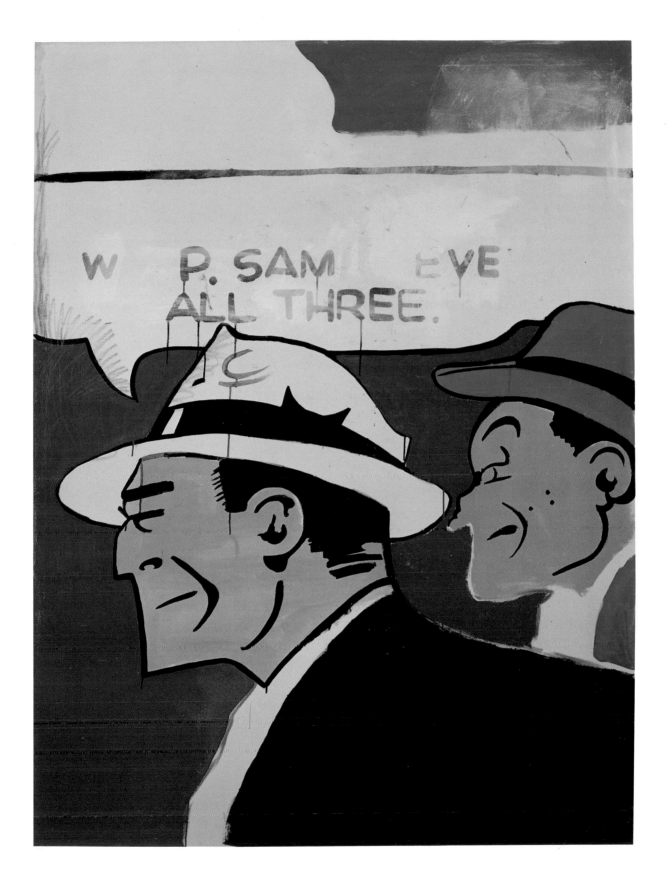

6 **Dick Tracy and Sam Ketchum** **1961** Collection David Geffen, Los Angeles

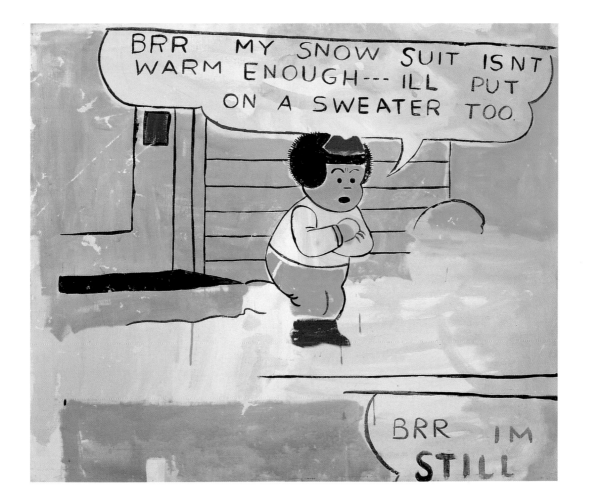

7 **Nancy** 1961 Private collection

8 A Boy for Meg [1] 1961 Private collection

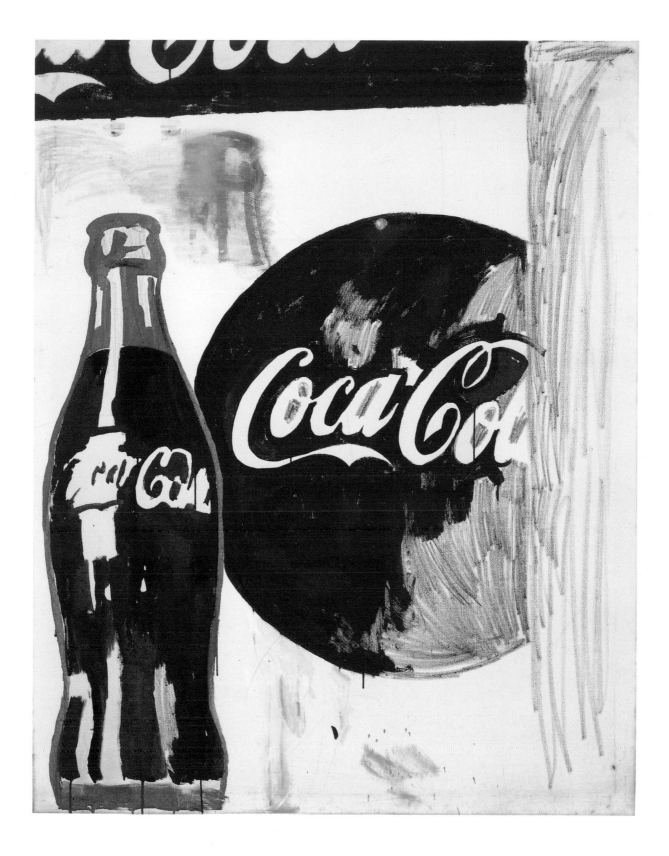

9 Coca-Cola [1] 1961 Private collection

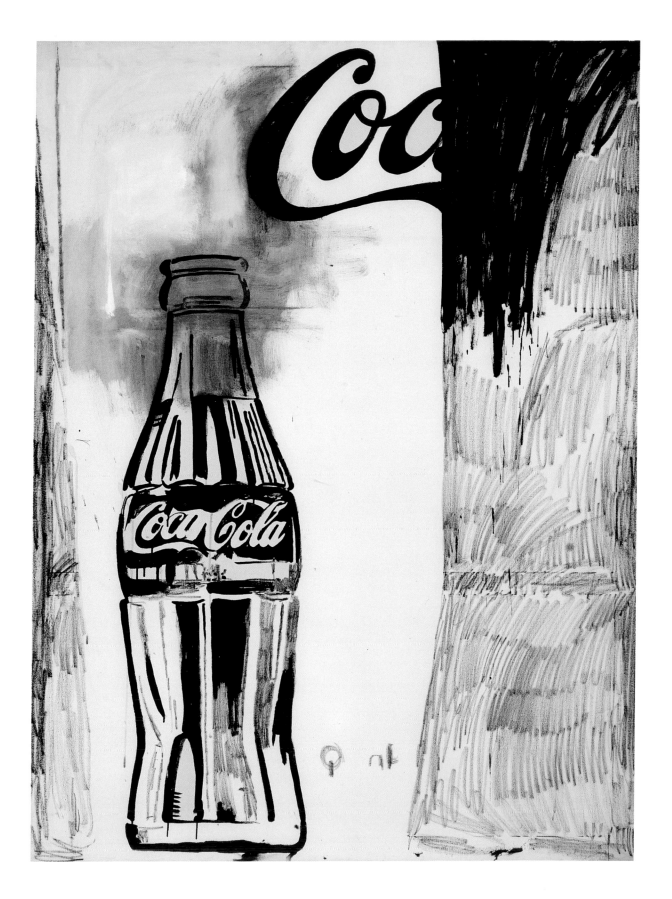

59

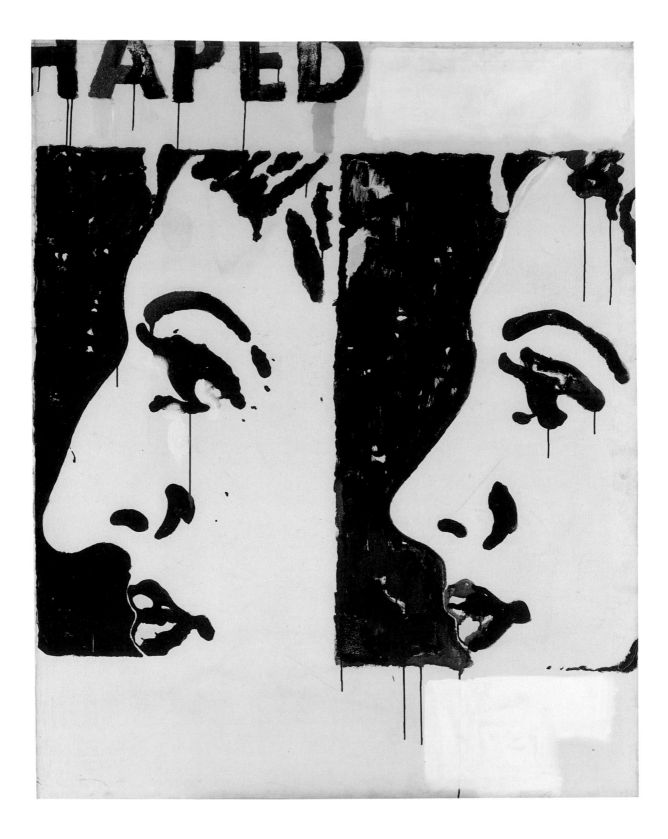

11 **Before and After [1]** **1961** The Metropolitan Museum of Art, New York. Gift of Halston, 1981

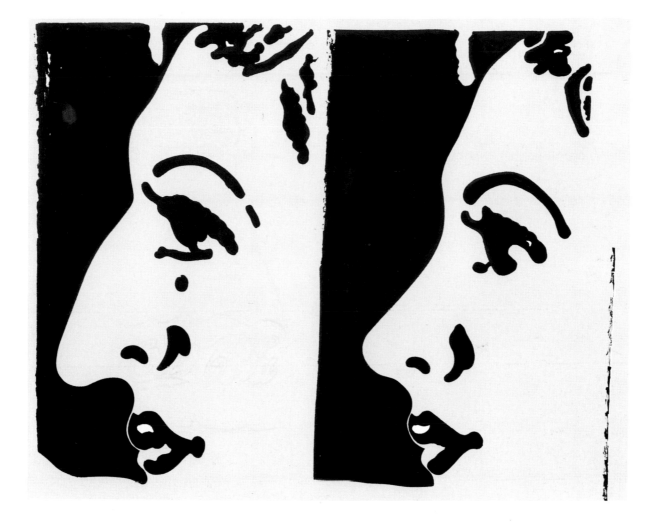

12 **Before and After [3]** **1961** Private collection, San Francisco

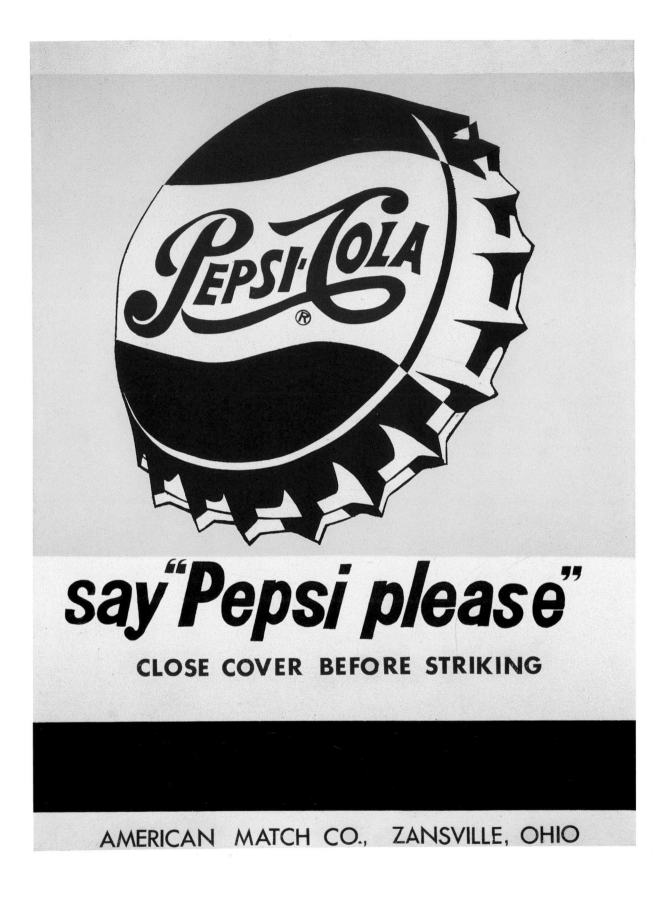

13 Close Cover Before Striking (Pepsi-Cola) 1962 Museum Ludwig, Cologne. Foundation Ludwig, 1976

63

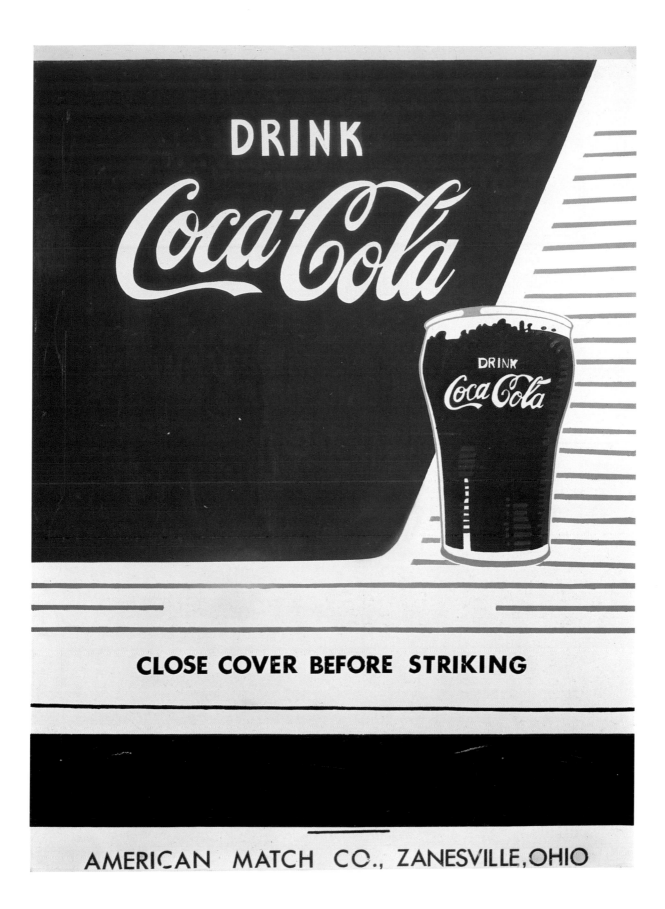

14 Close Cover Before Striking (Coca-Cola) 1962 Louisiana Museum of Modern Art, Humlebæk, Denmark

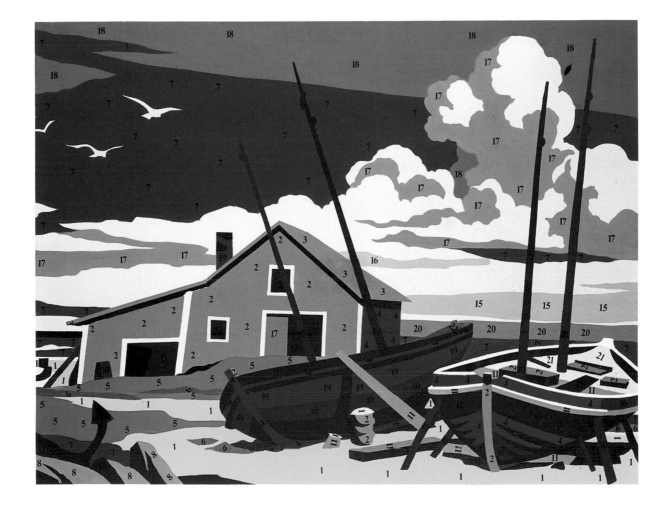

15 **Do It Yourself (Seascape) 1962** Staatliche Museen zu Berlin, Nationalgalerie, Collection Marx

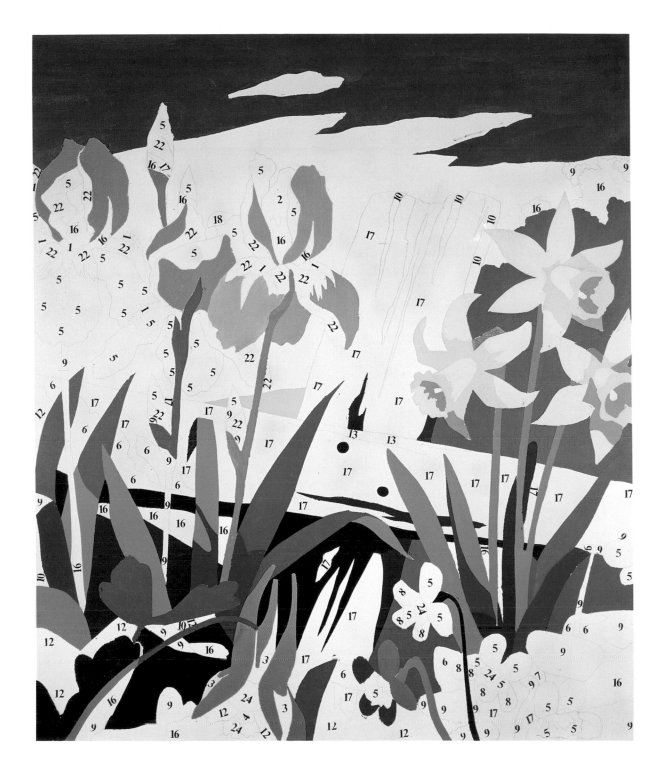

16 **Do It Yourself (Flowers) 1962** Daros Collection, Switzerland

17 **Do It Yourself (Violin) 1962** Private collection

18 **Do It Yourself (Landscape) 1962** Museum Ludwig, Cologne. Foundation Ludwig, 1976

START

19 **Dance Diagram [4] 1962** Moderna Museet, Stockholm

START

20 Dance Diagram [3] 1962 Private collection

21 Dance Diagram [6] 1962 Daros Collection, Switzerland

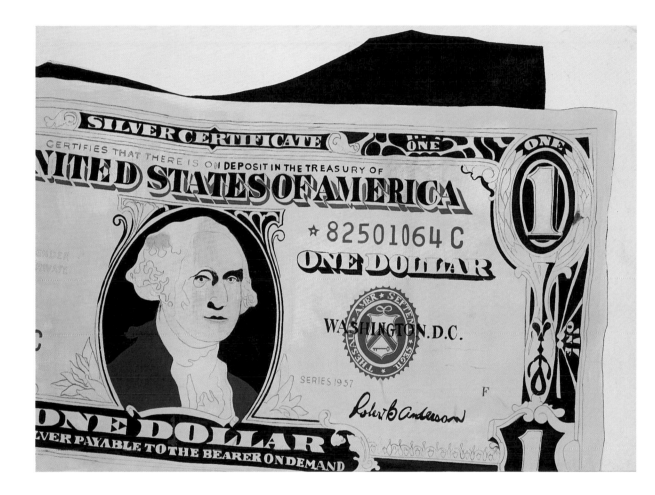

22 One Dollar Bill—Silver Certificate 1962 Private collection, Switzerland

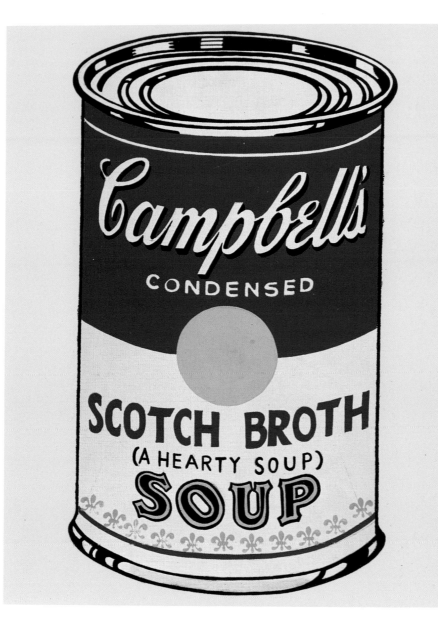

23 Campbell's Soup Can (Scotch Broth) 1962 Collection Uli Knecht

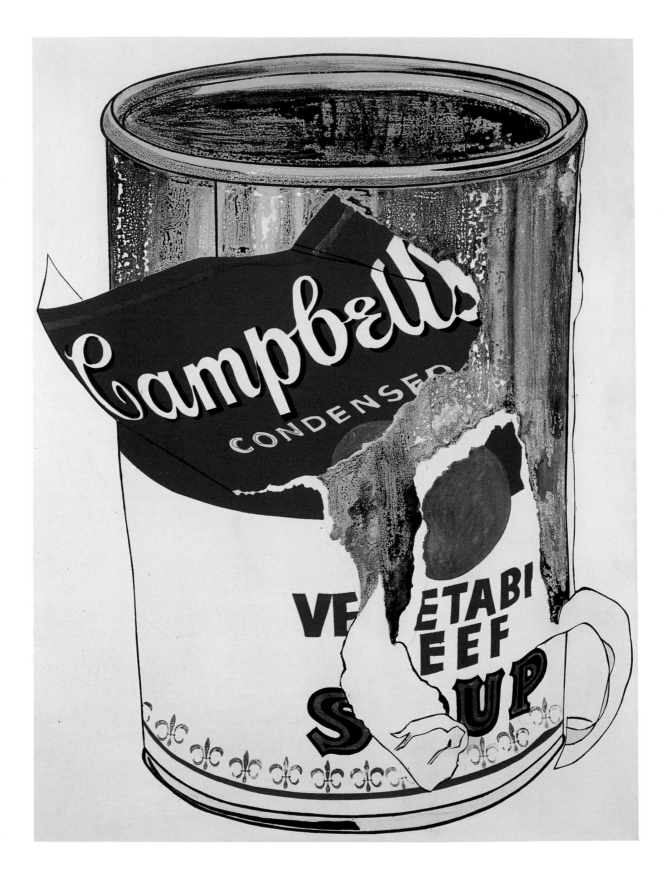

24 **Big Torn Campbell's Soup Can (Vegetable Beef) 1962** Kunsthaus Zürich

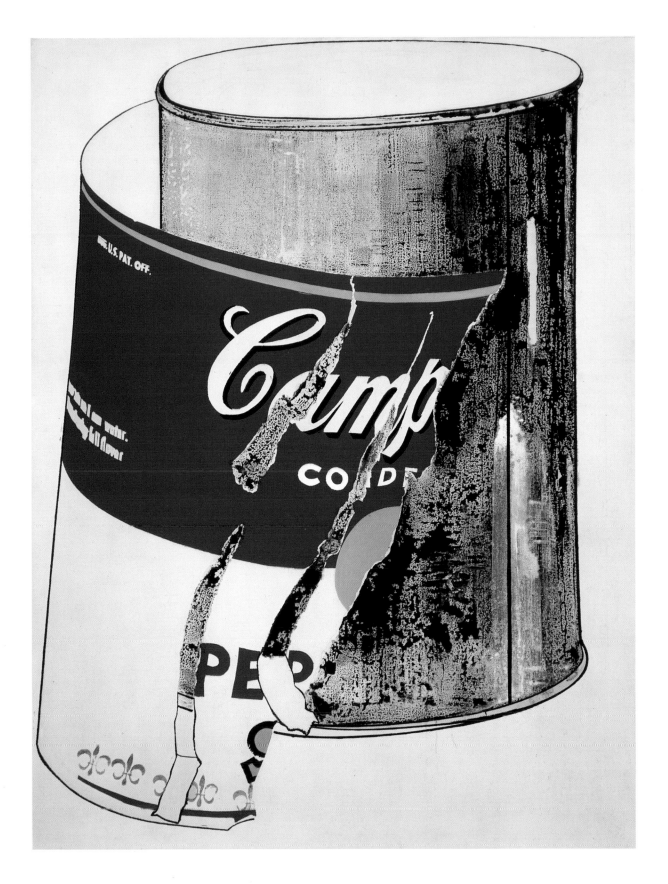

25　Big Torn Campbell's Soup Can (Pepper Pot)　1962　Private collection, Switzerland

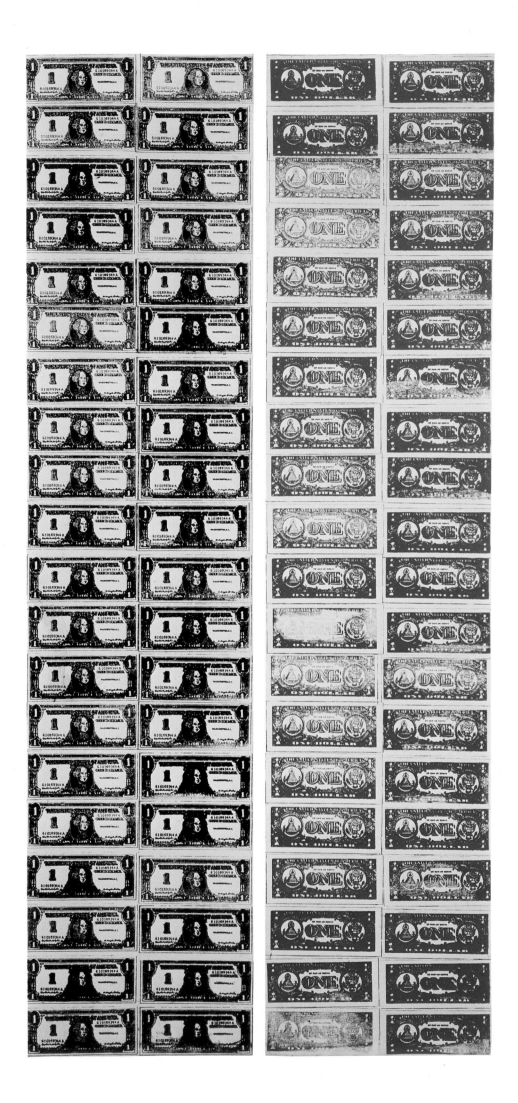

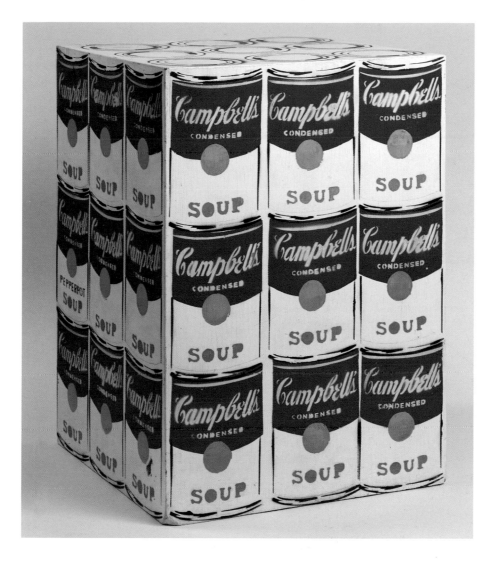

← **26** **Front and Back Dollar Bills** **1962** Private collection, Switzerland

27 **Campbell's Soup Box** **1962** The Andy Warhol Museum, Pittsburgh; Founding Collection, Contribution The Andy Warhol Foundation for the Visual Arts, Inc.

28 100 Cans 1962 Albright-Knox Art Gallery, Buffalo, New York. Gift of Seymour H. Knox, Jr., 1963

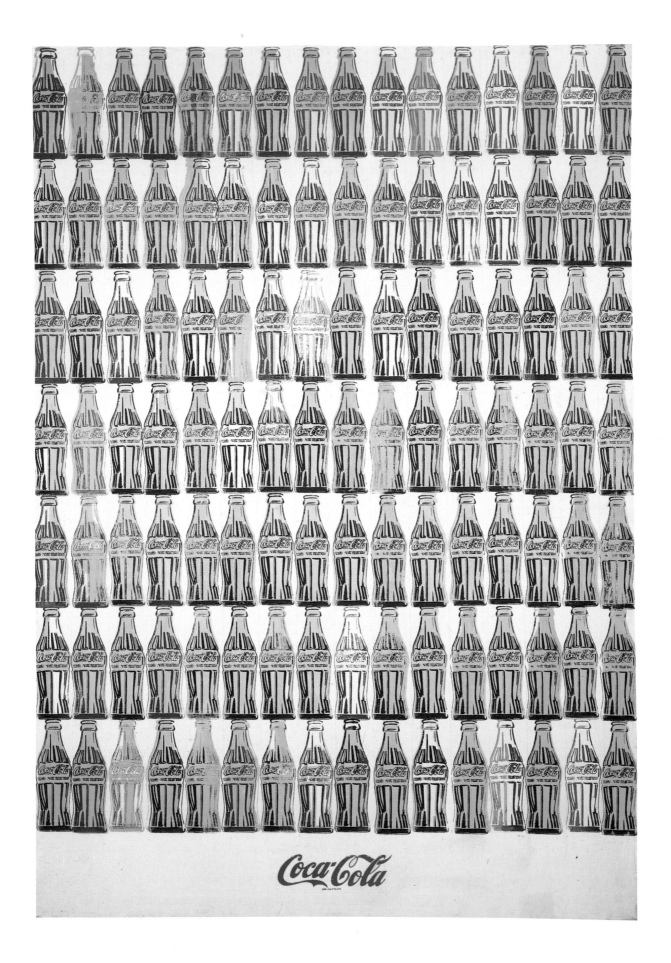

29 Green Coca-Cola Bottles 1962 Whitney Museum of American Art, New York. Purchase, with funds from the Friends of the Whitney Museum of American Art

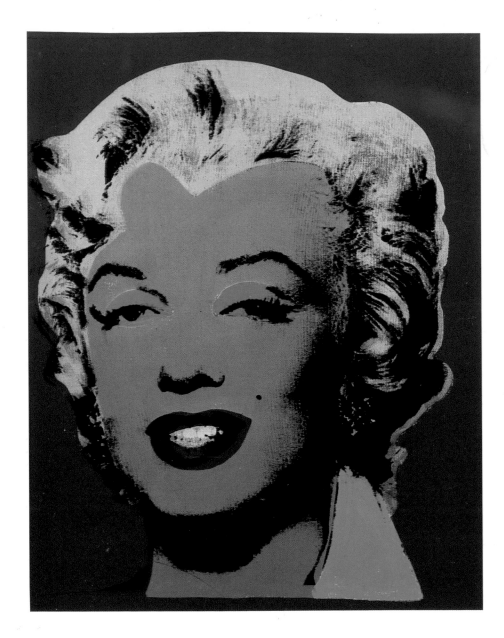

30 Cherry Marilyn 1962 Private collection

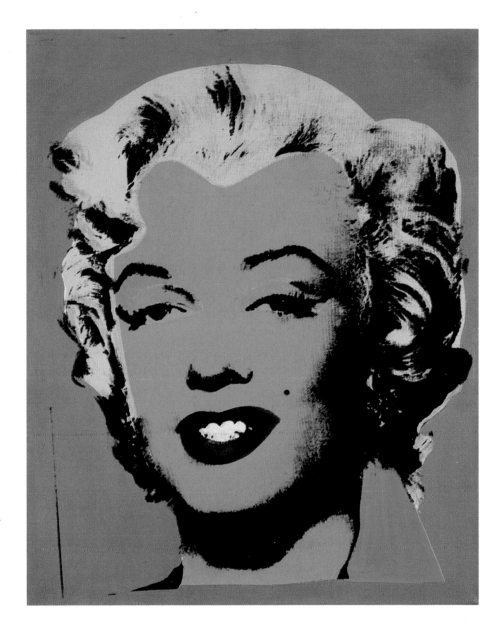

31 **Lavender Marilyn [2] 1962** Collection Uli Knecht

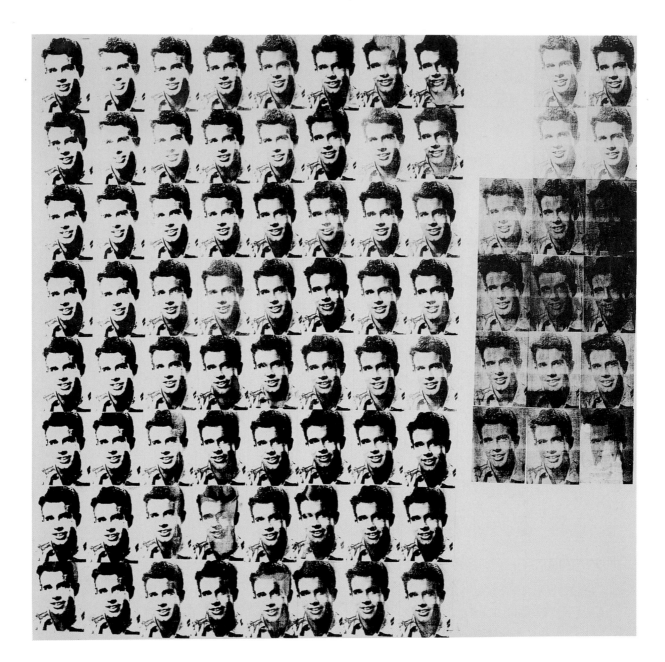

32 Warren 1962 Private collection

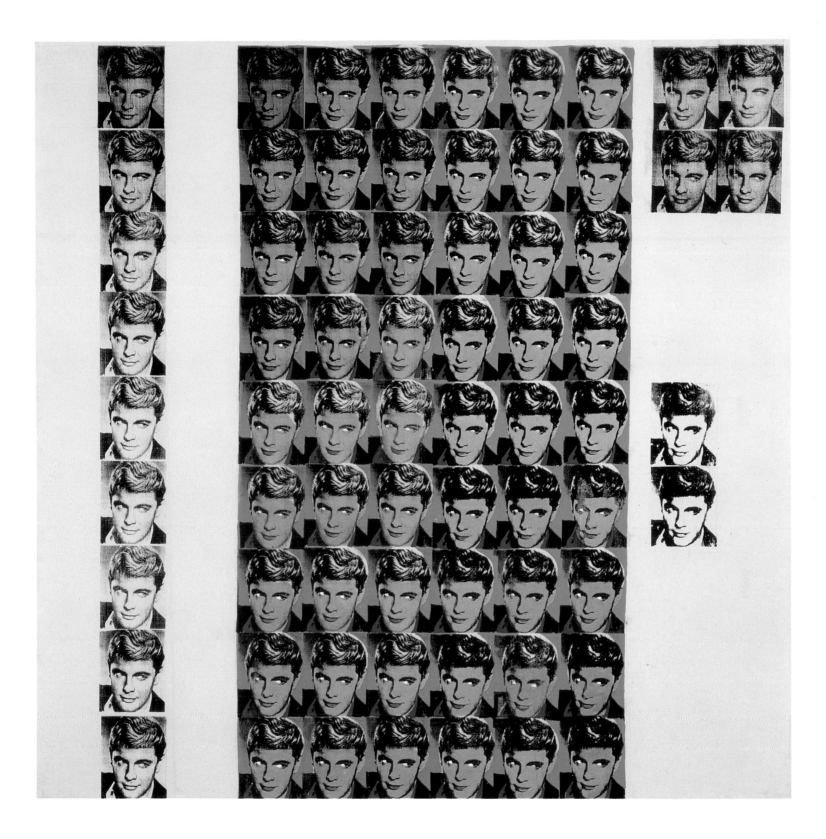

33 Troy 1962 Private collection, Courtesy Massimo Martino Fine Arts & Projects, Mendrisio

ETW. LEXINGTON AVENUE AND 3RD AVENUE ON 87TH STREET

ERDIL'S
TAILORING
ALTERATIONS
410-7662

ERDIL'S
TAILOR
410-7662

KESSIE & CO.

Sam's
TAILOR

88

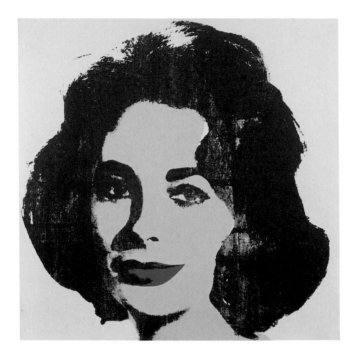

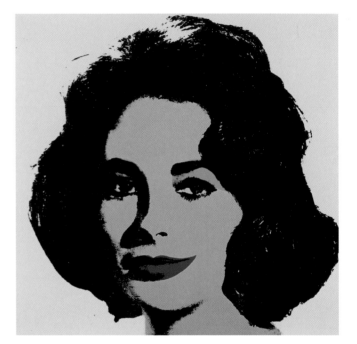

34 **Liz #1** **1963** Sonnabend Collection

35 **Liz #2** **1963** Private collection

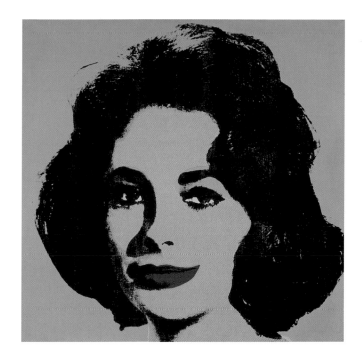 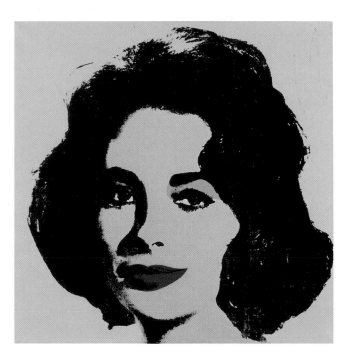

36 **Liz #5 1963** Sonnabend Collection 37 **Liz #3 1963** Private collection

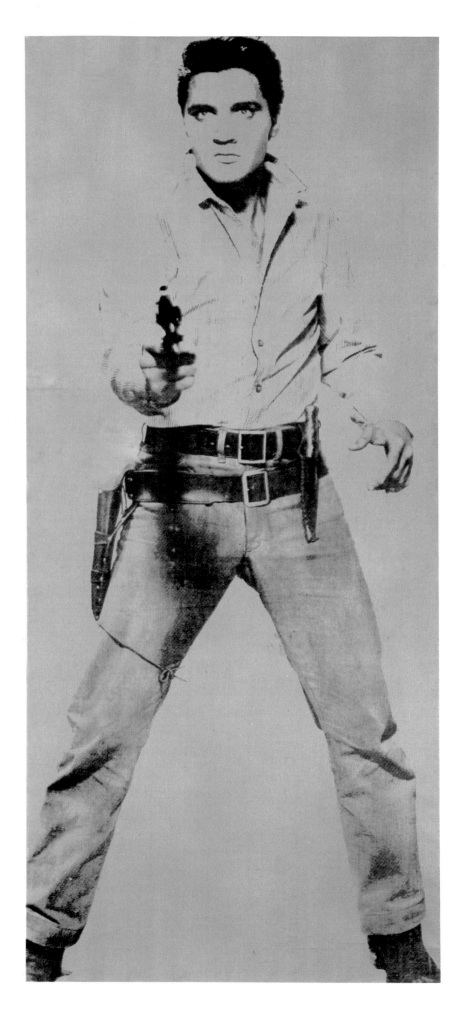

38 **Single Elvis 1963** Collection National Gallery of Australia, Canberra

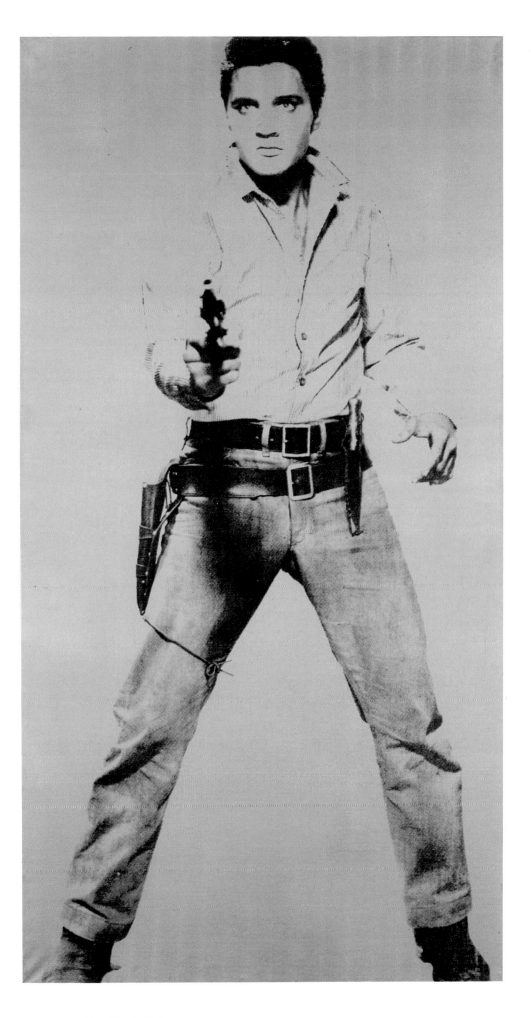

39 **Single Elvis** 1963 Museum of Contemporary Art – Ludwig Museum, Budapest

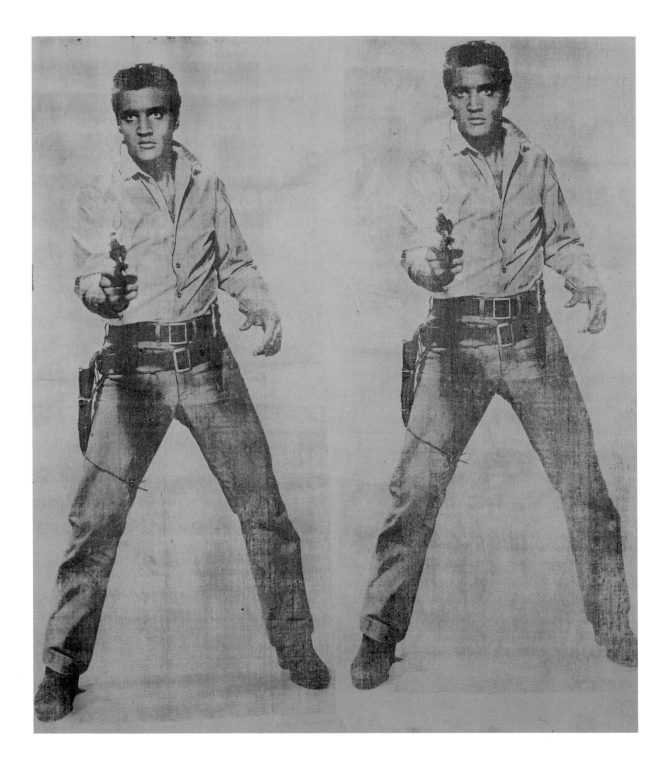

40 Elvis 2 Times 1963 Private collection, USA

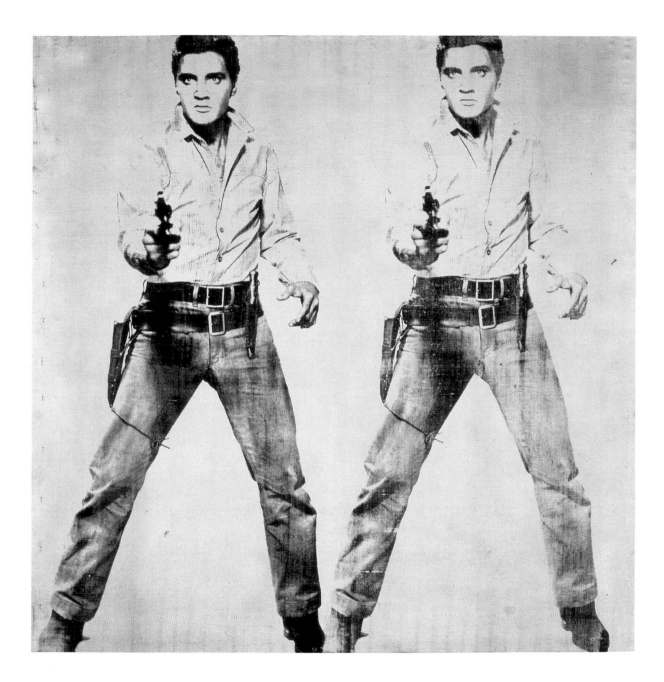

41 **Double Elvis** 1963 Private collection

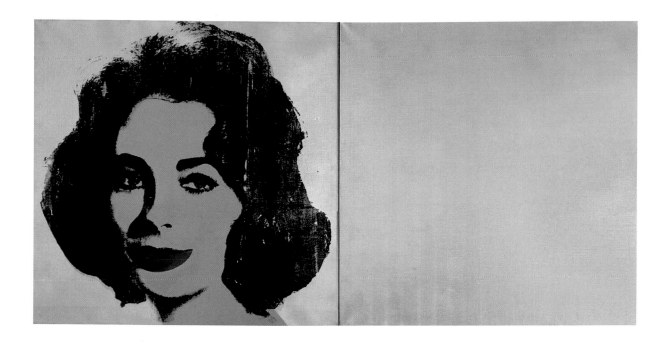

42 **Silver Liz** **1963** Private collection

43 **White Disaster** **1963** Private collection

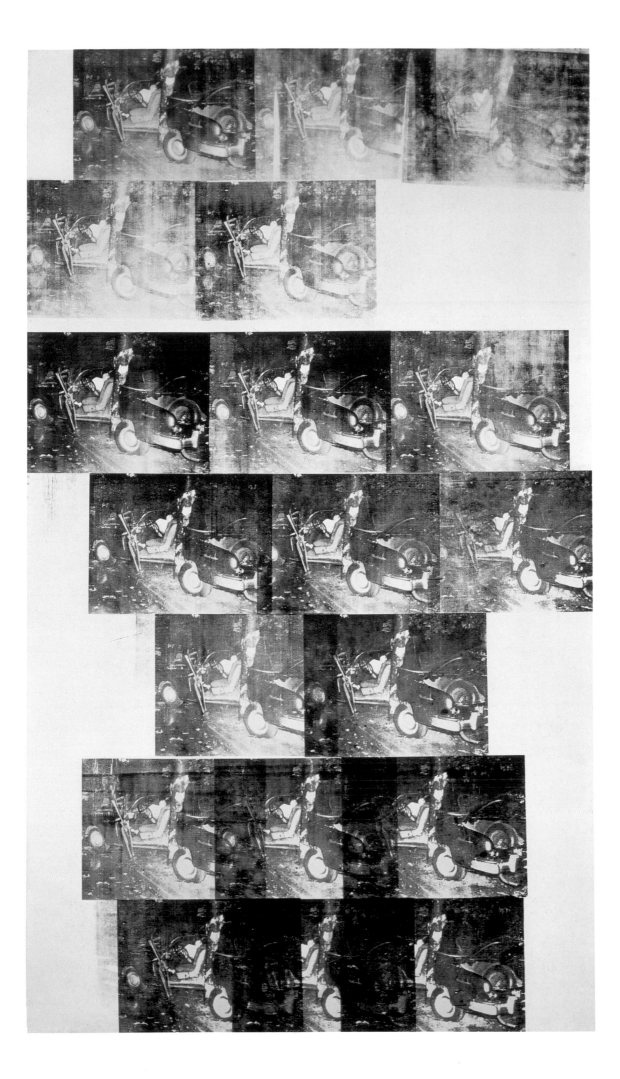

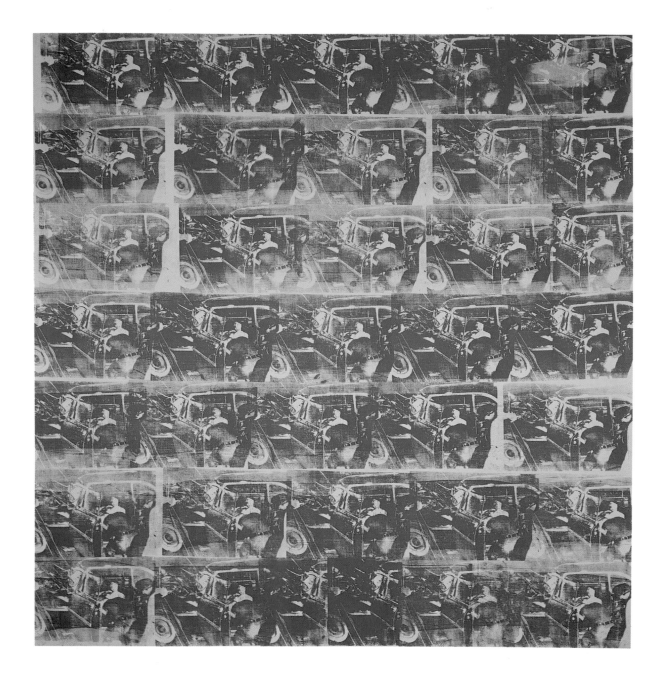

44 **Green Car Crash** **1962** Private collection

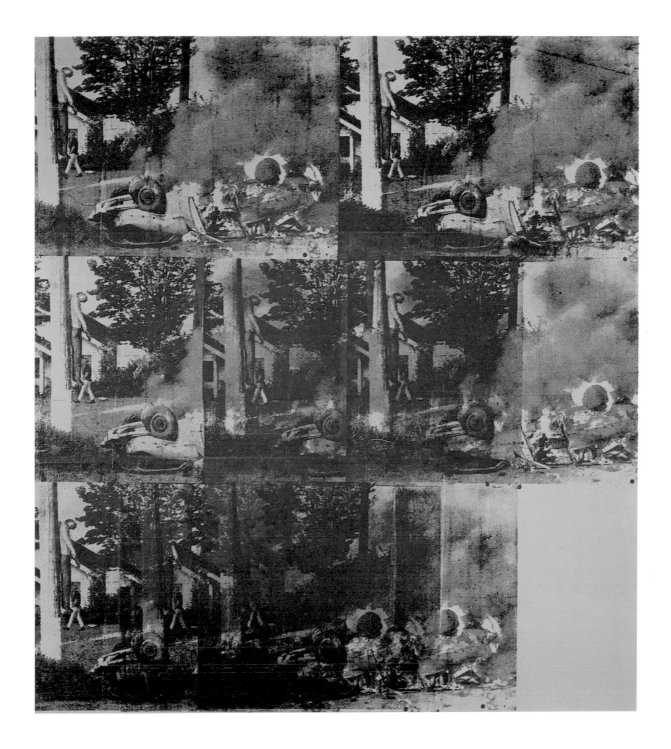

45 Green Burning Car I 1963 Private collection

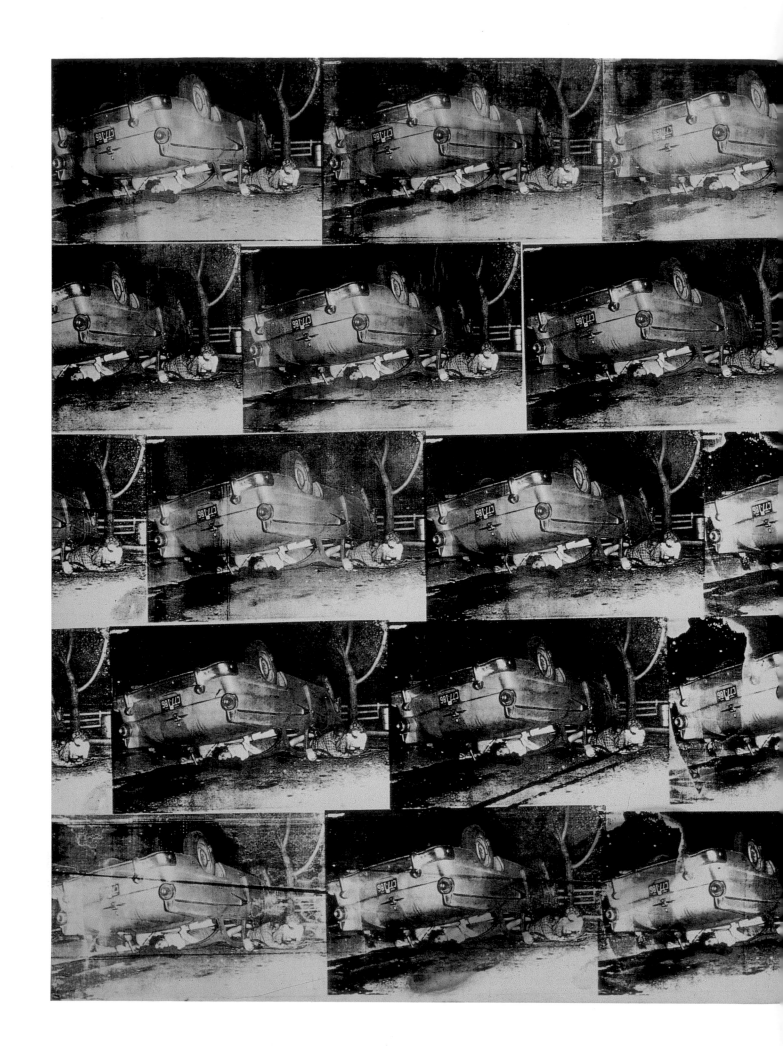

46 **Black and White Disaster #4 1963** Öffentliche Kunstsammlung Basel, Kunstmuseum

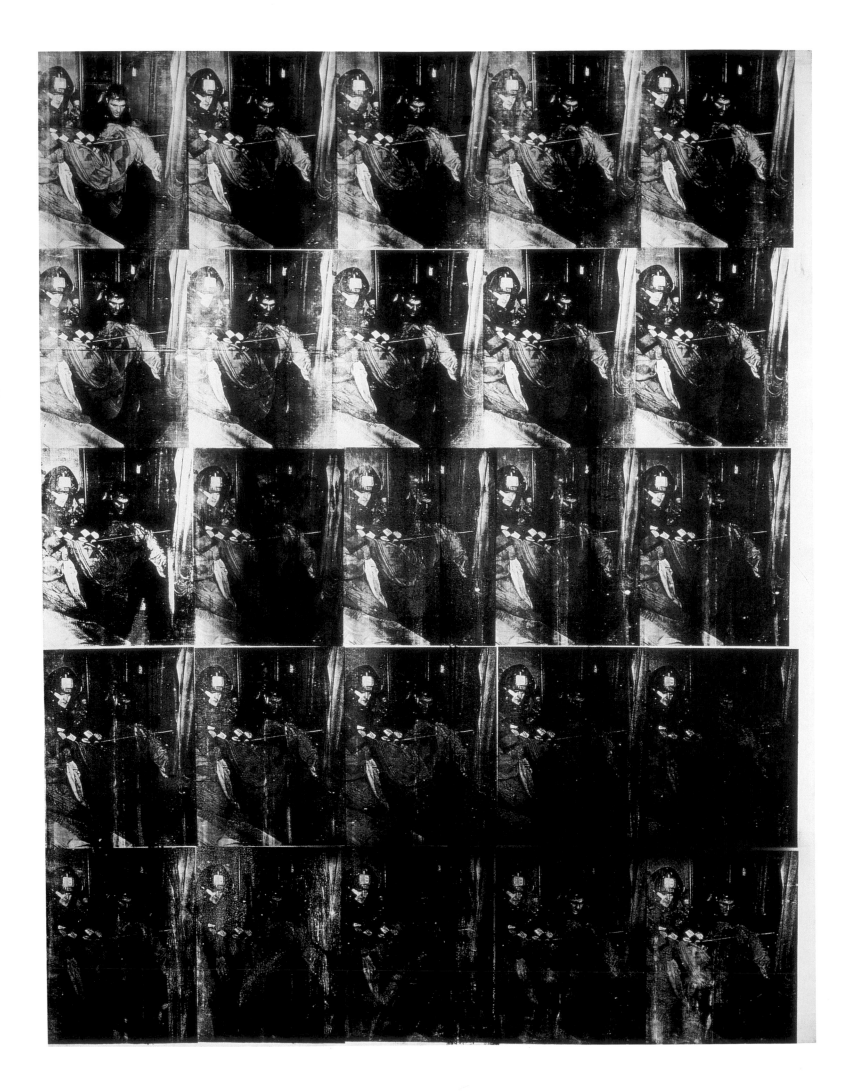

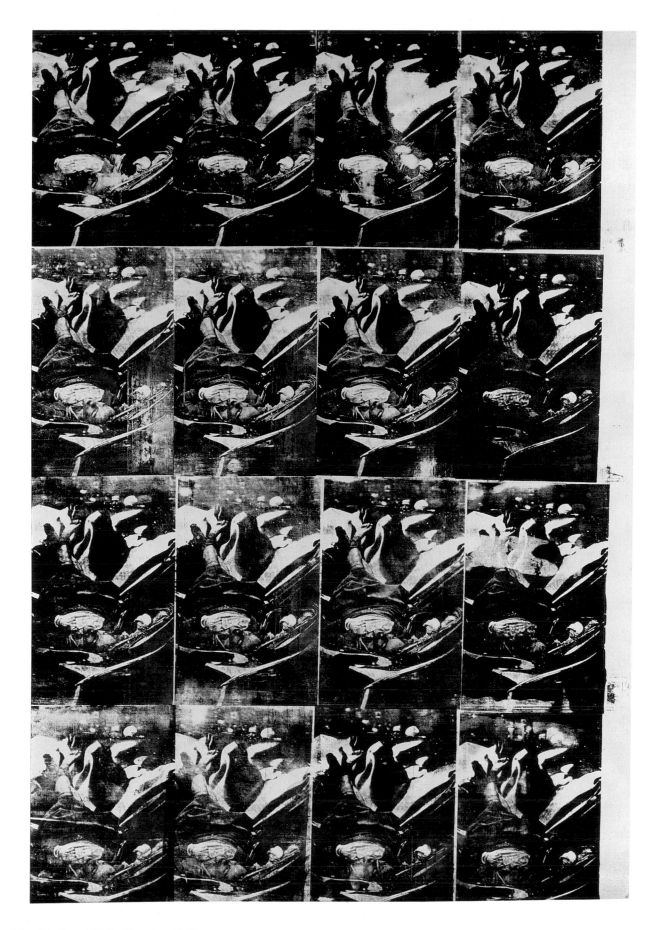

← 52 **Black and White Disaster** **1963** Los Angeles County Museum of Art, Gift of Leo Castelli Gallery and Ferus Gallery through the Contemporary Art Council

53 **Suicide (Fallen Body)** **1963** Private collection

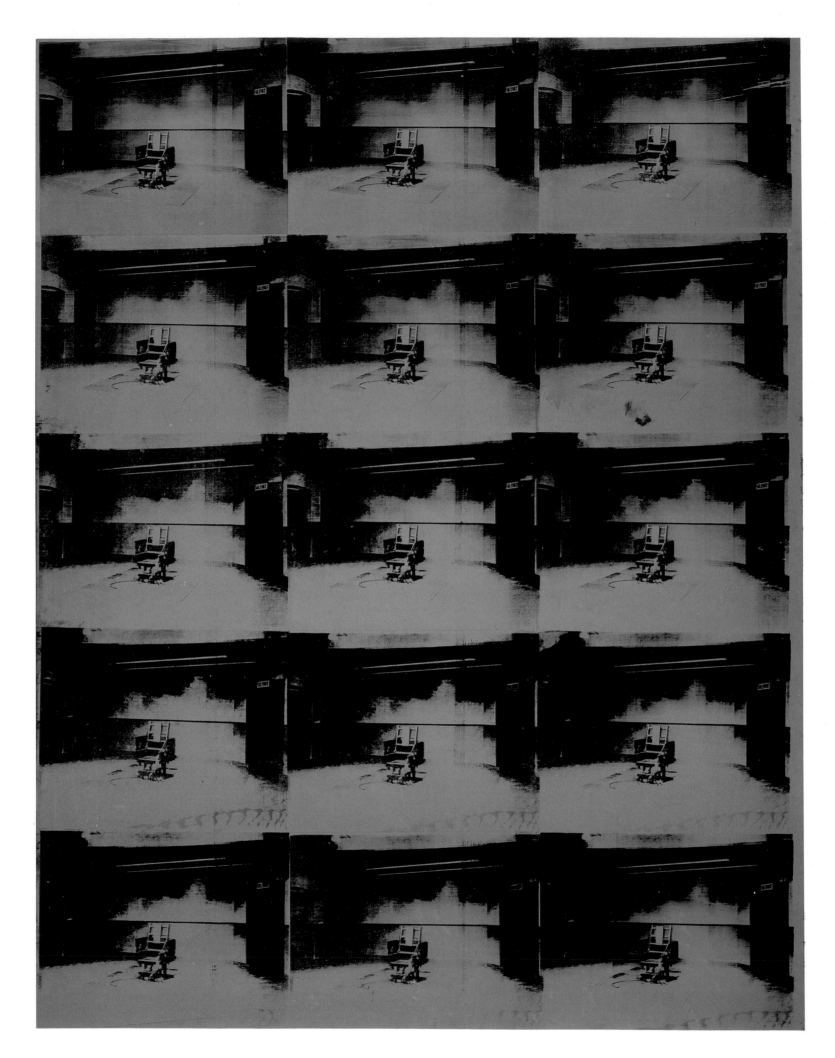

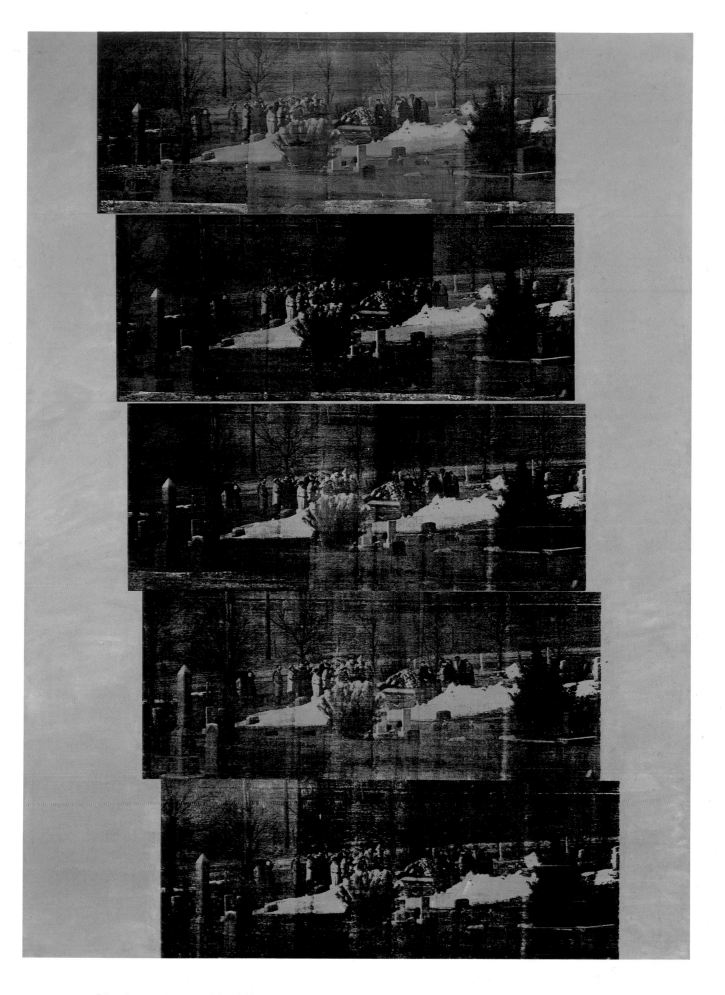

← 54 **Orange Disaster #5 1963** Solomon R. Guggenheim Museum, New York. Gift, Harry N. Abrams Family Collection, 1974

55 **Gangster Funeral 1963** The Andy Warhol Museum, Pittsburgh; Founding Collection, Contribution Dia Center for the Arts

114

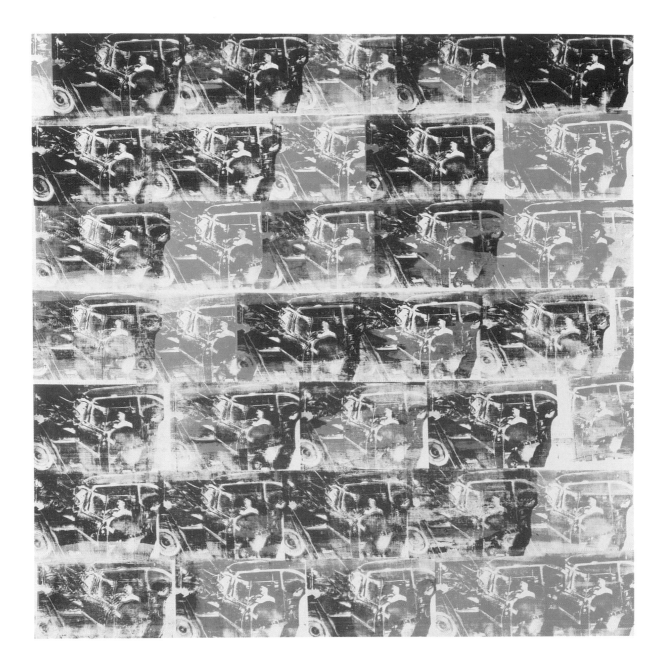

57 Optical Car Crash 1962 Öffentliche Kunstsammlung Basel, Kunstmuseum

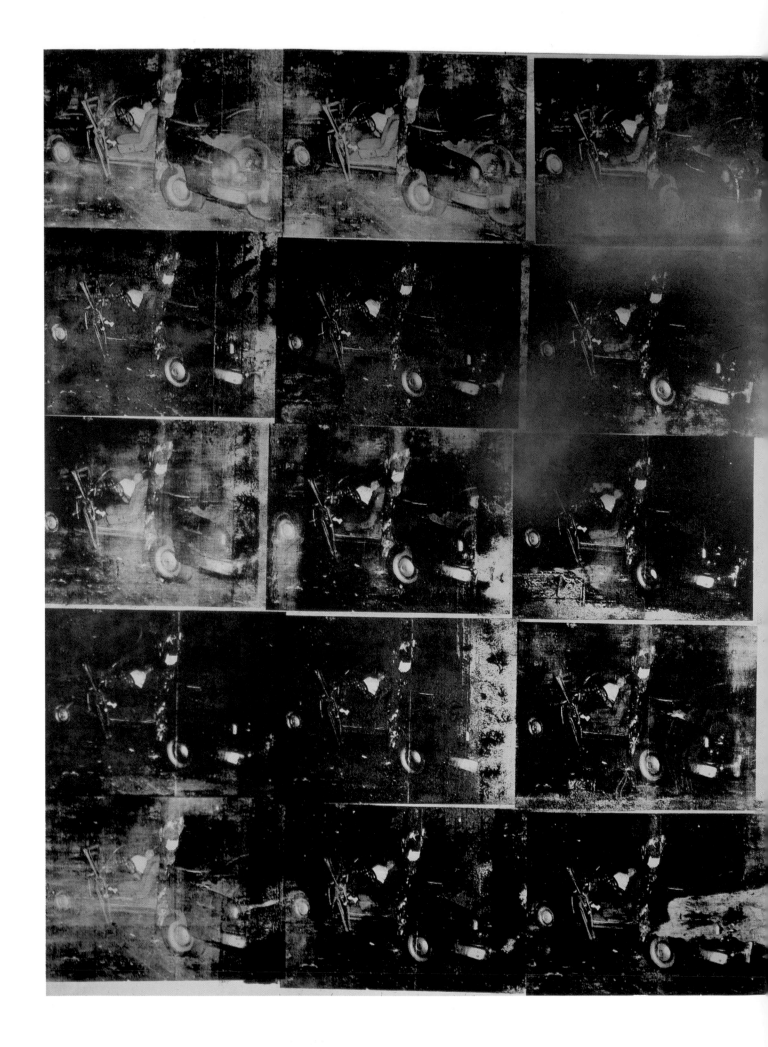

58 **Silver Car Crash 1963** Private collection

FACTORY (TORN DOWN IN 1970–71) 231 EAST 47TH STREET

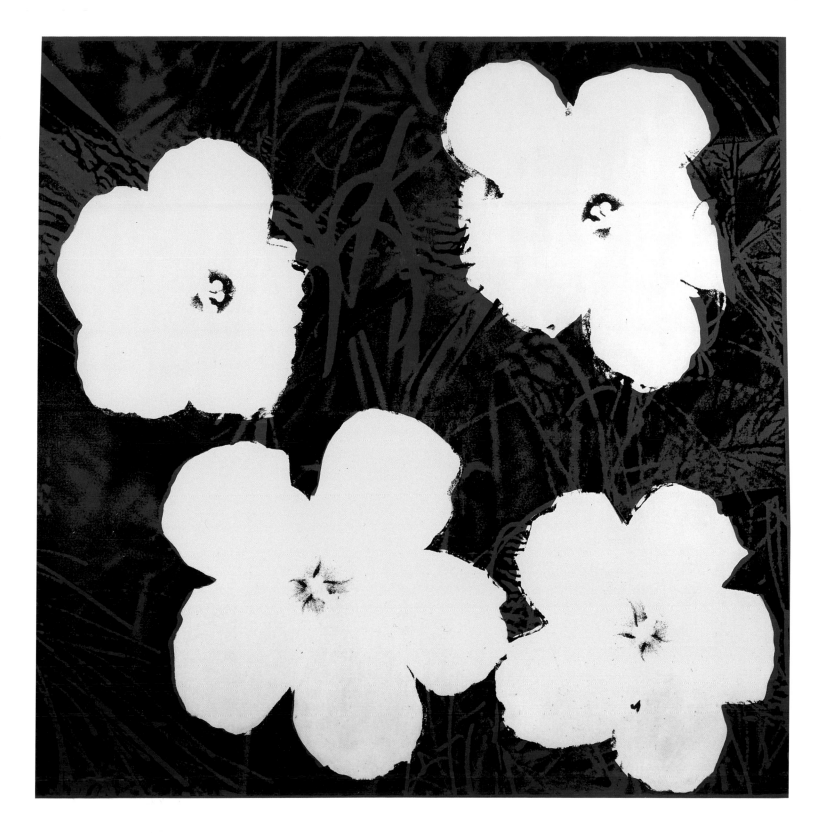

59 Flowers 1964 Private collection

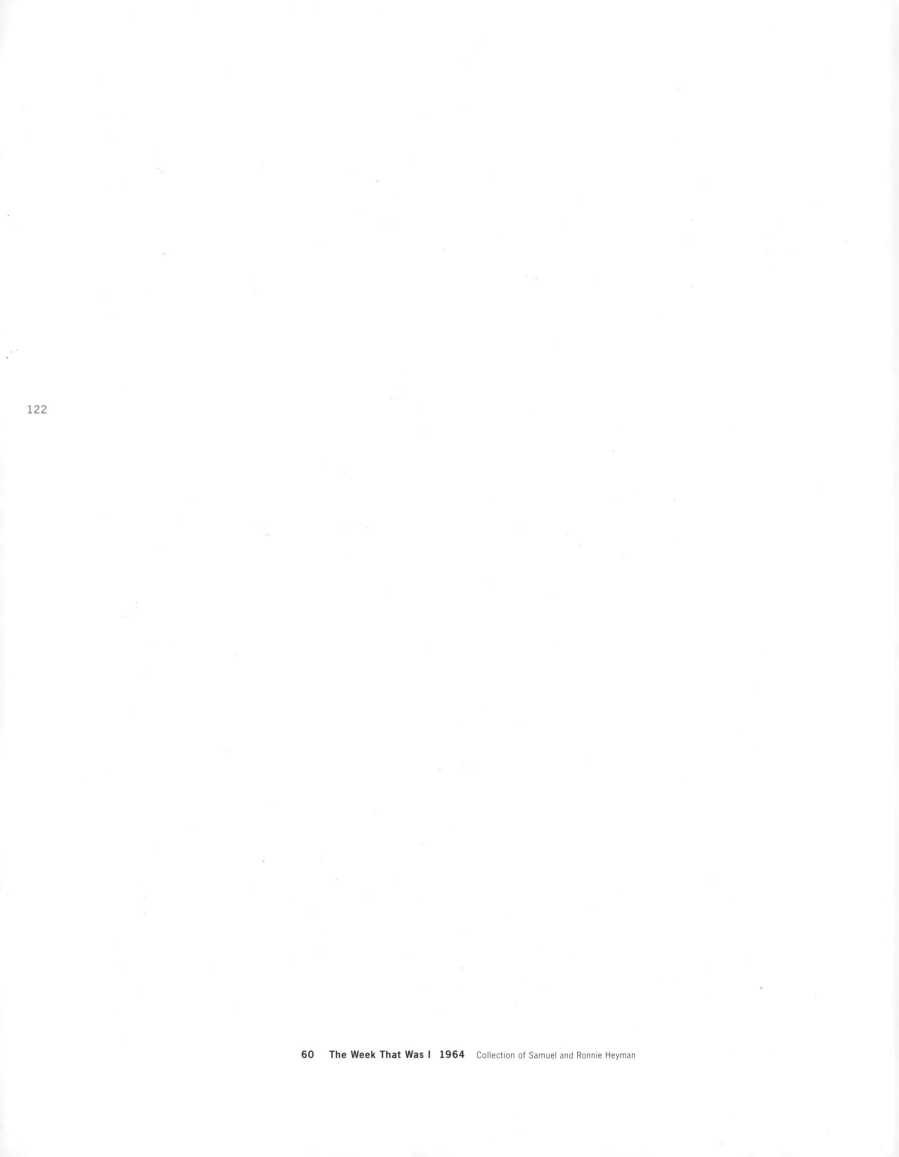

60 The Week That Was I 1964 Collection of Samuel and Ronnie Heyman

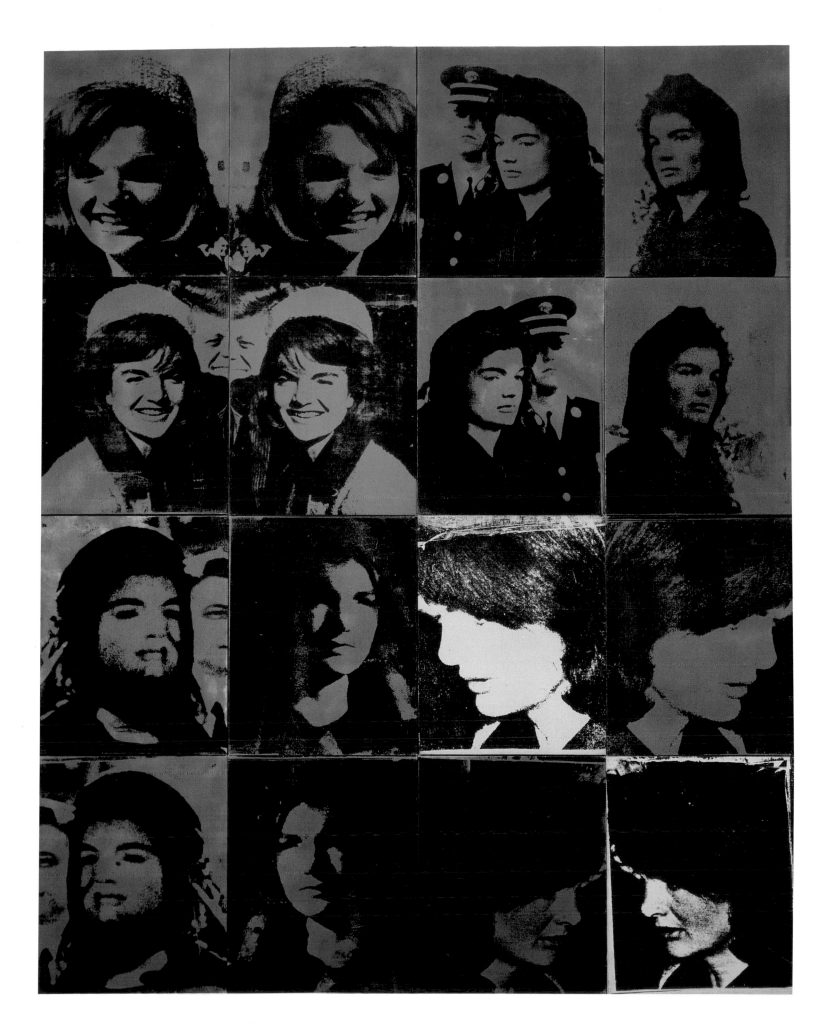

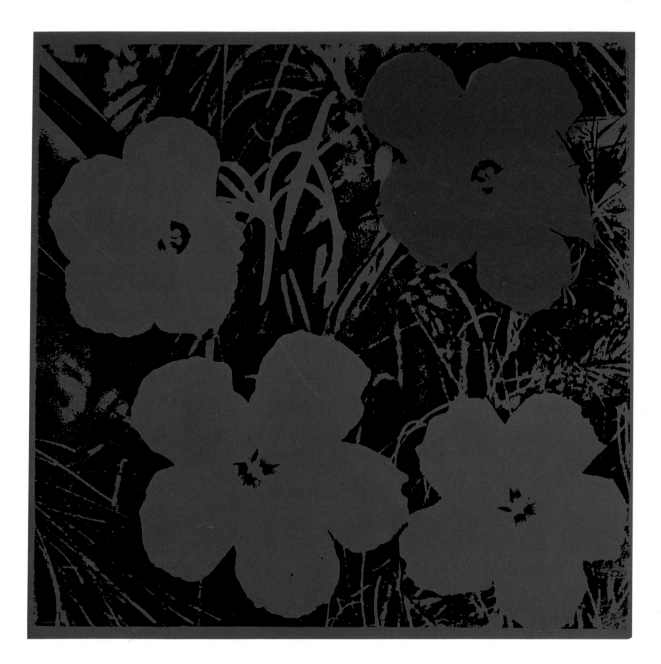

61 Four-Foot Flowers 1964 The National Museum of Art, Osaka

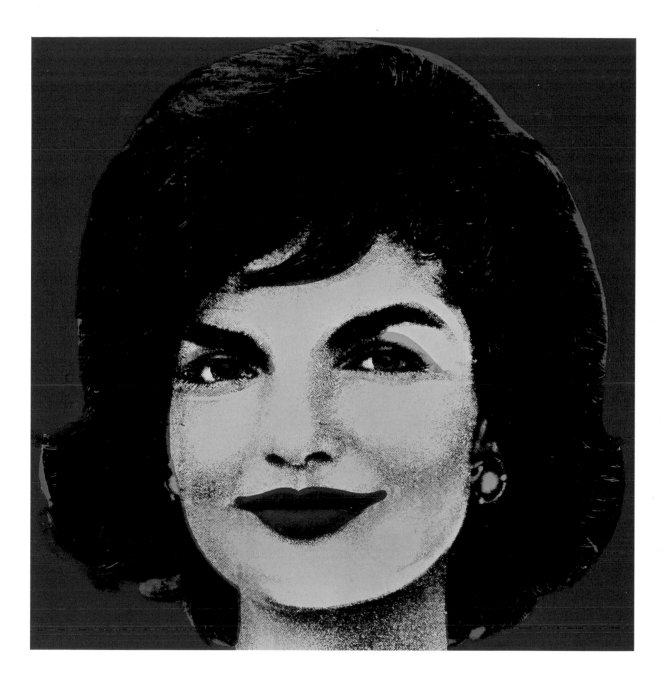

62 Red Jackie 1964 Collection Froehlich, Stuttgart

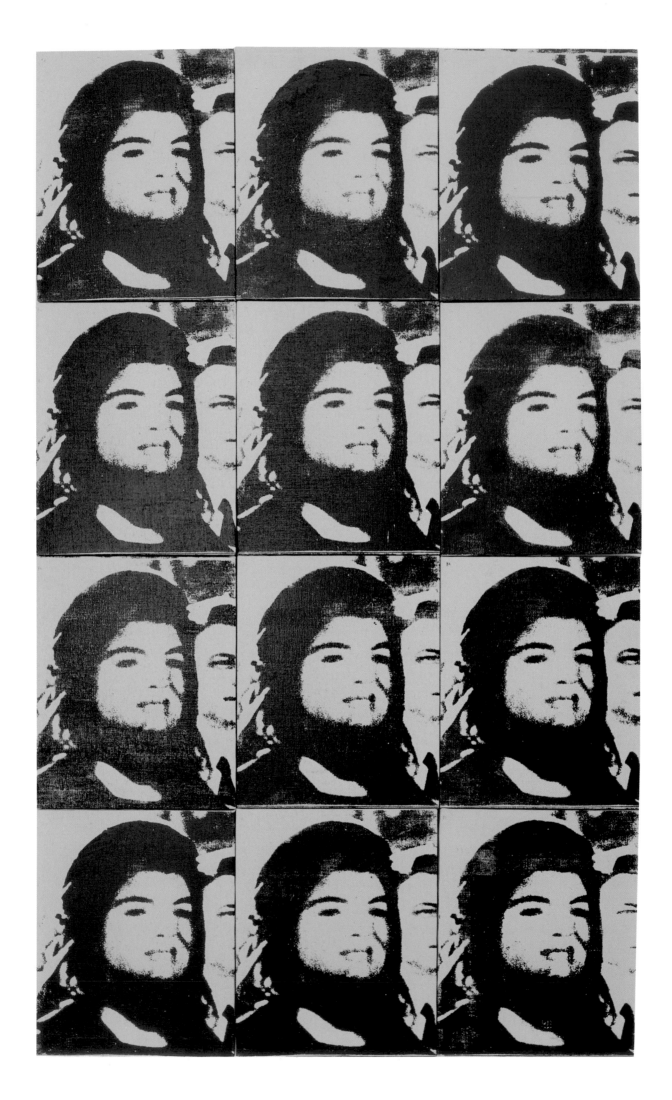

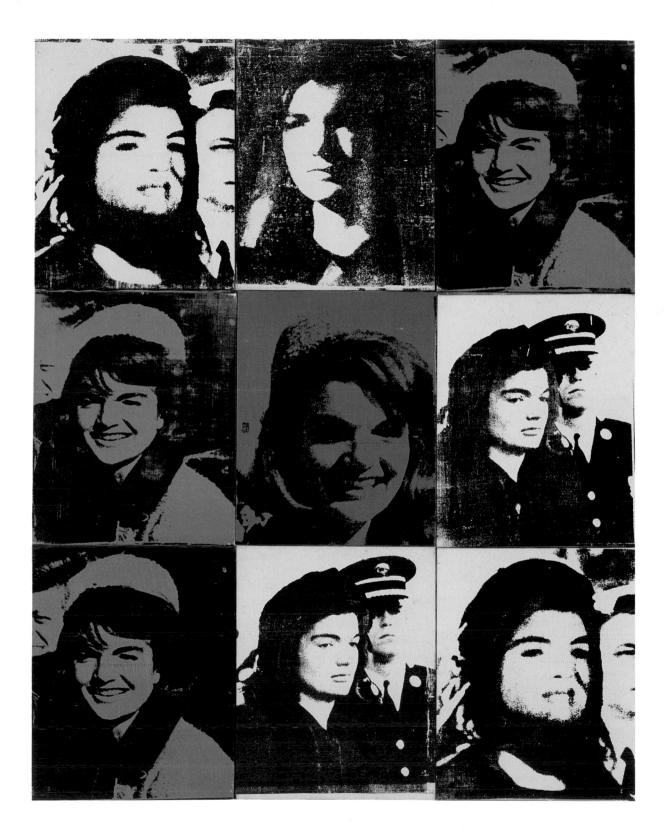

← 63 **Twelve Jackies** 1964 Collection Hauser & Wirth, St. Gallen, Switzerland 64 **Nine Jackies** 1964 Sonnabend Collection

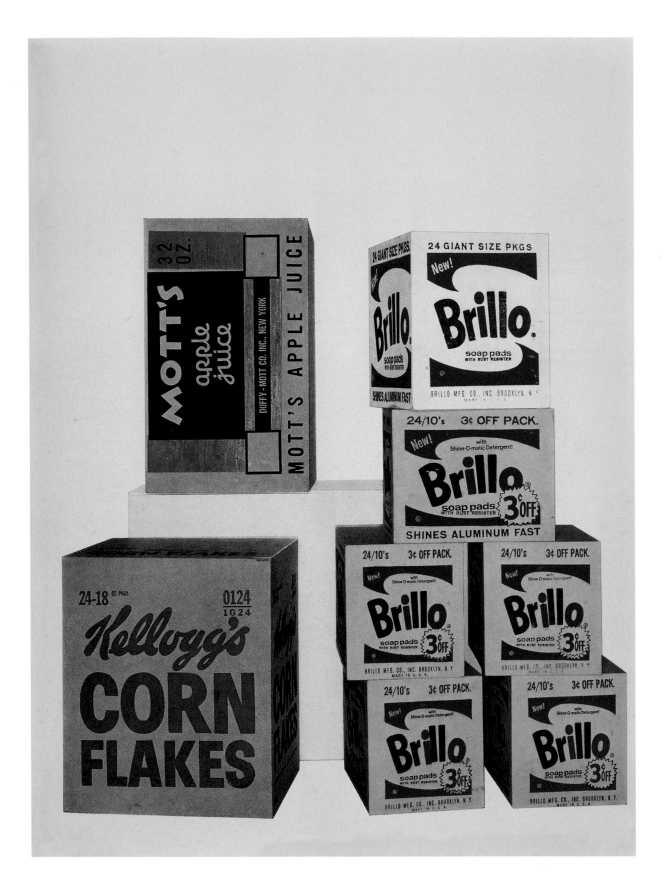

65 Brillo Box, Brillo Box 3c off, Kellogg's Cornflakes Box, Mott's Apple Juice Box 1964 Museum für Moderne Kunst, Frankfurt a. M., Former Collection Ströher, Darmstadt

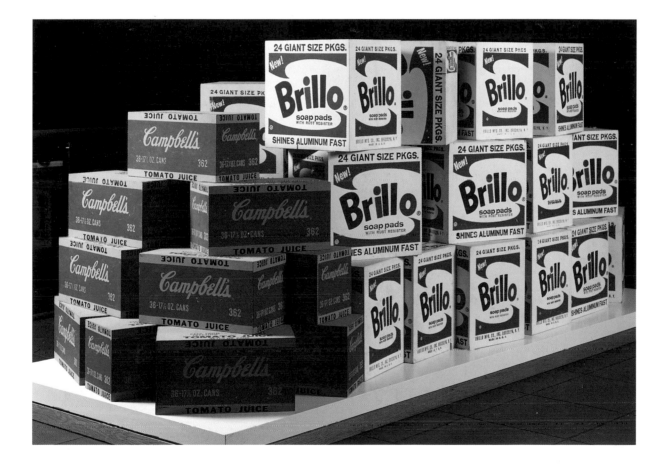

66 **Brillo Box, Campbell's Tomato Juice Box 1964** Museum Ludwig, Cologne. Collection Ludwig

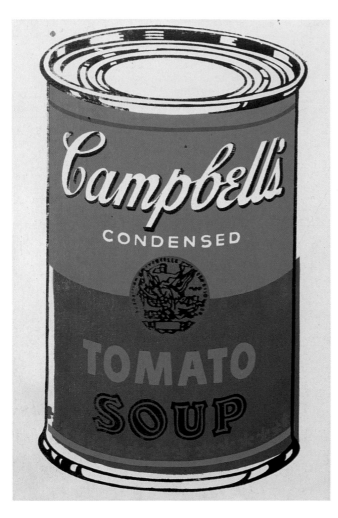

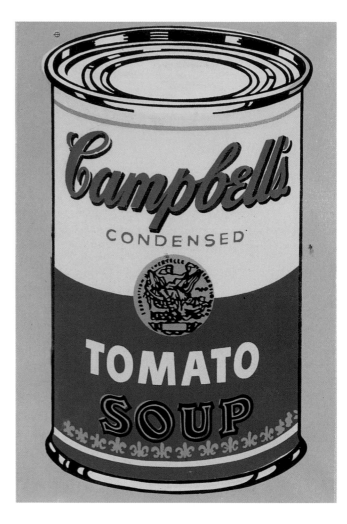

67 **Colored Campbell's Soup Can** **1965** Sonnabend Collection

68 **Colored Campbell's Soup Can** **1965** Sonnabend Collection

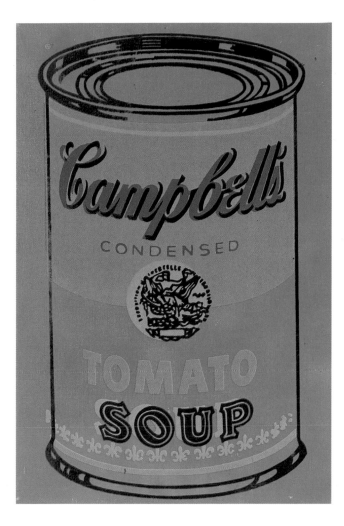

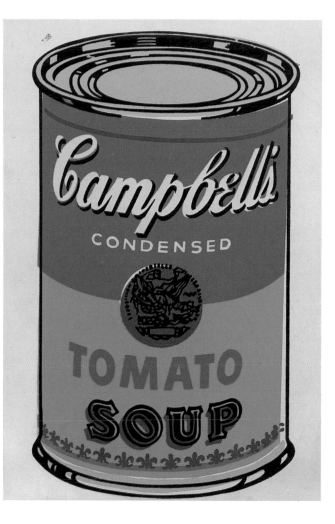

69 Colored Campbell's Soup Can 1965 Sonnabend Collection

70 Colored Campbell's Soup Can 1965 Sonnabend Collection

132

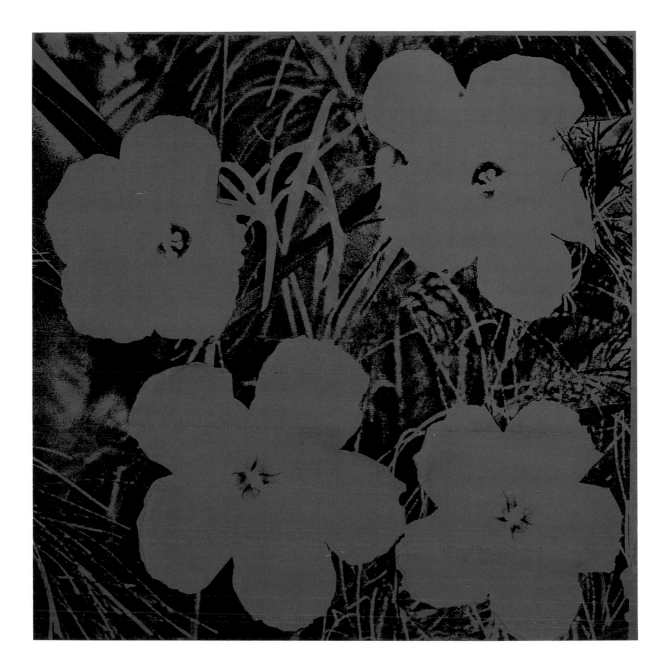

71 **Flowers 1964** Hirshhorn Museum and Sculpture Garden, Smithsonian Institution, Washington, D.C., Joseph H. Hirshhorn Bequest, 1981

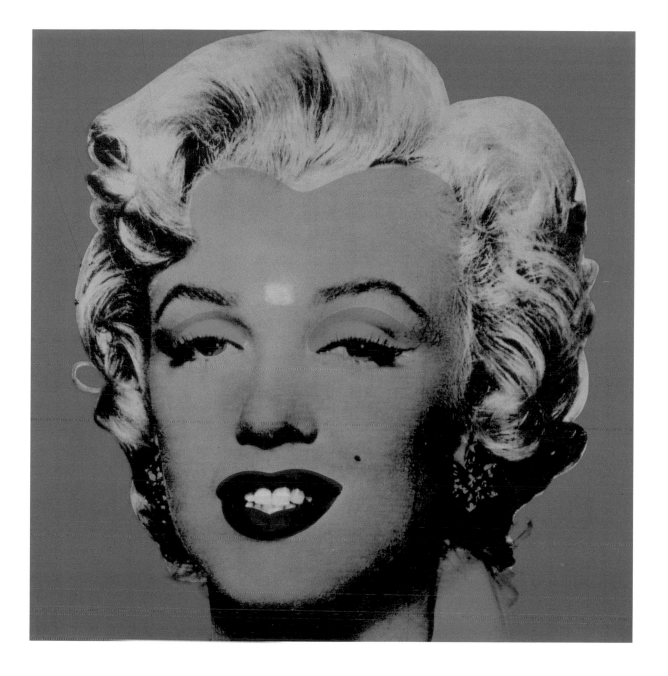

73 **Shot Light Blue Marilyn** **1964** Courtesy The Brant Foundation, Greenwich, CT

138

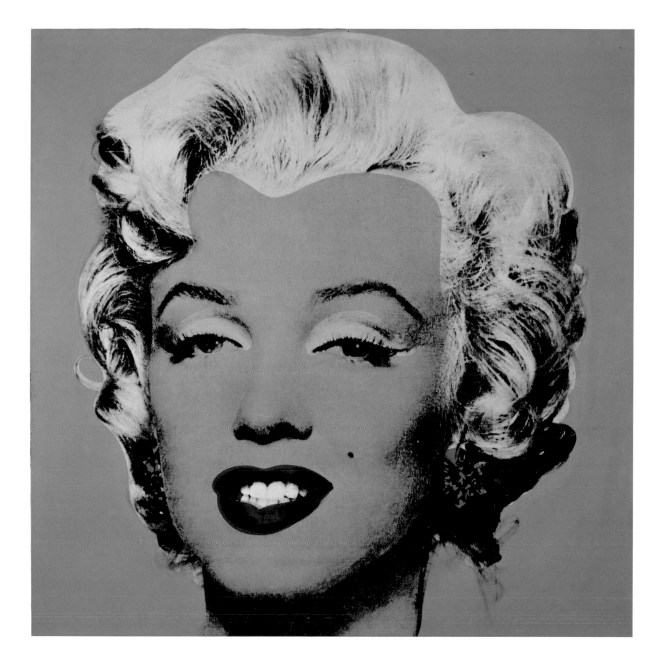

74 Turquoise Marilyn 1964 Stefan T. Edlis Collection

140

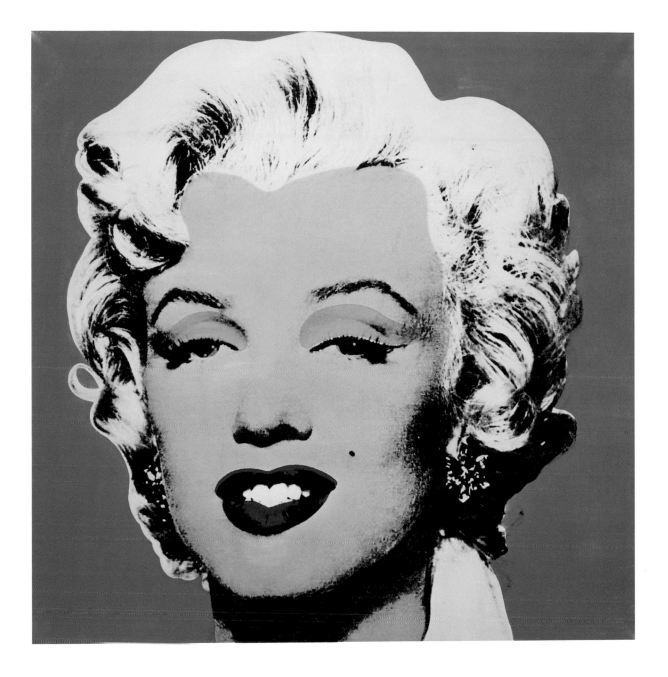

75 **Shot Orange Marilyn 1964** Private collection

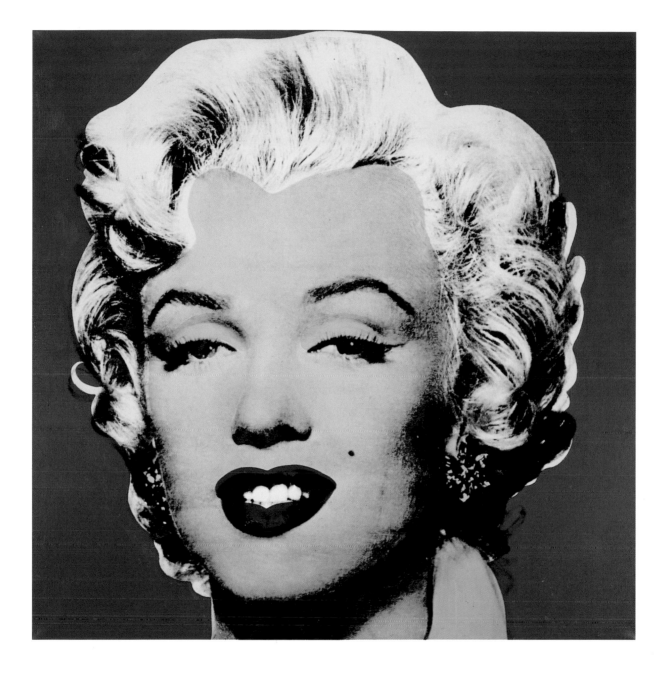

76 **Shot Red Marilyn** **1964** Private collection

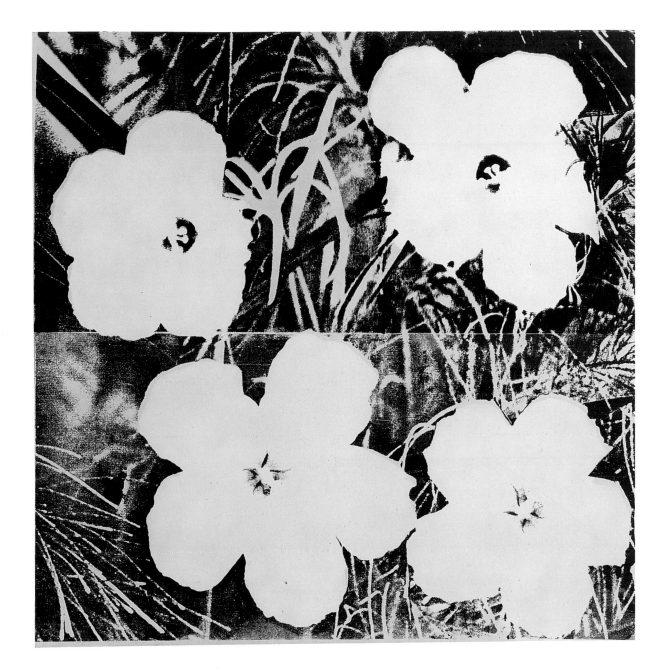

77 **Flowers** 1964 Fondation Beyeler, Riehen/Basle

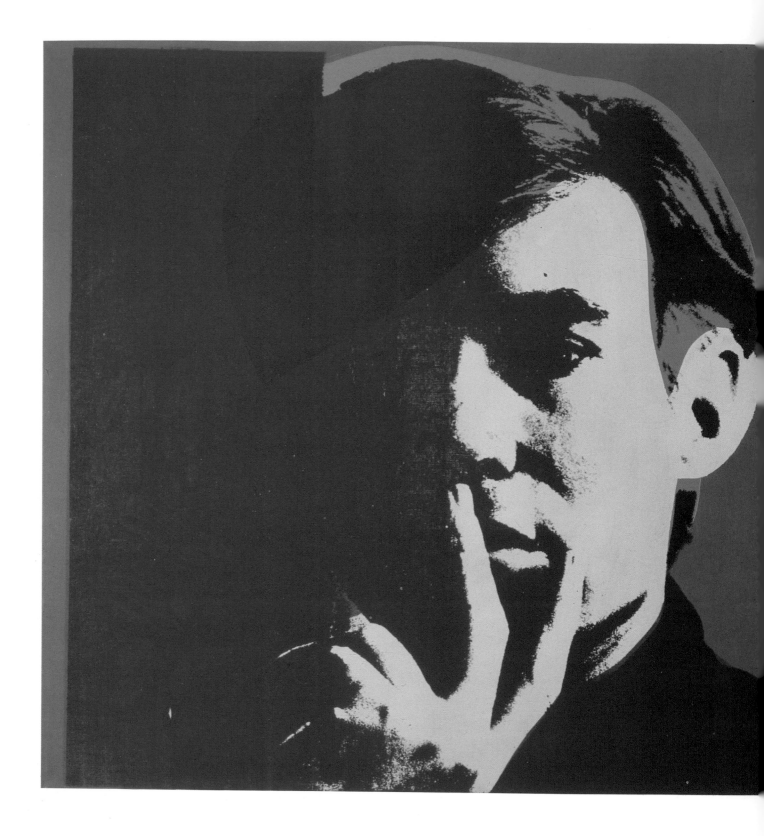

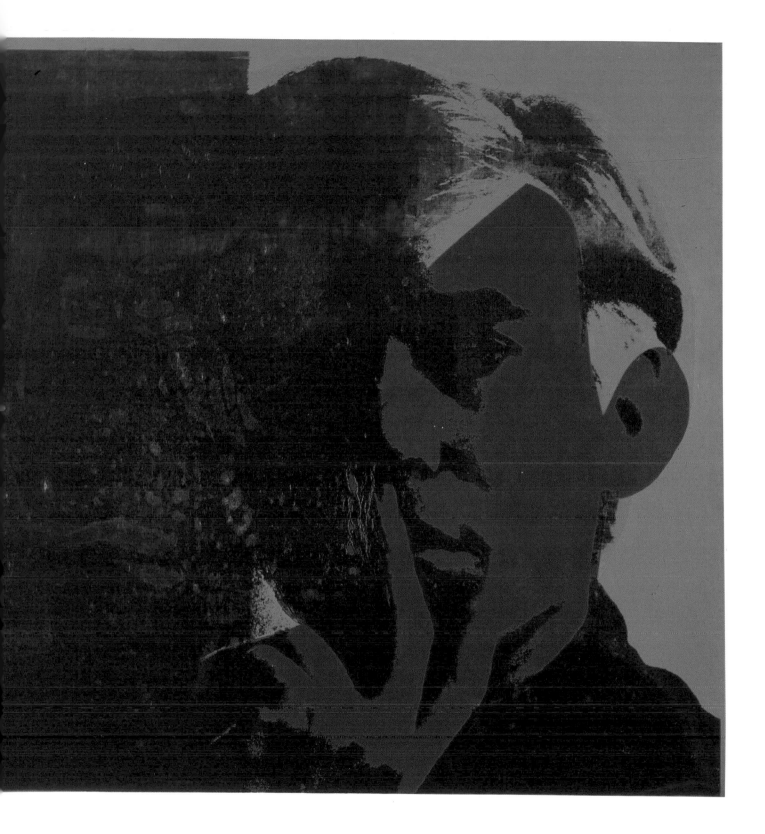

78 **Double Self-Portrait** **1967** The Detroit Institute of Arts, Founders Society Purchase, Friends of Modern Art Fund

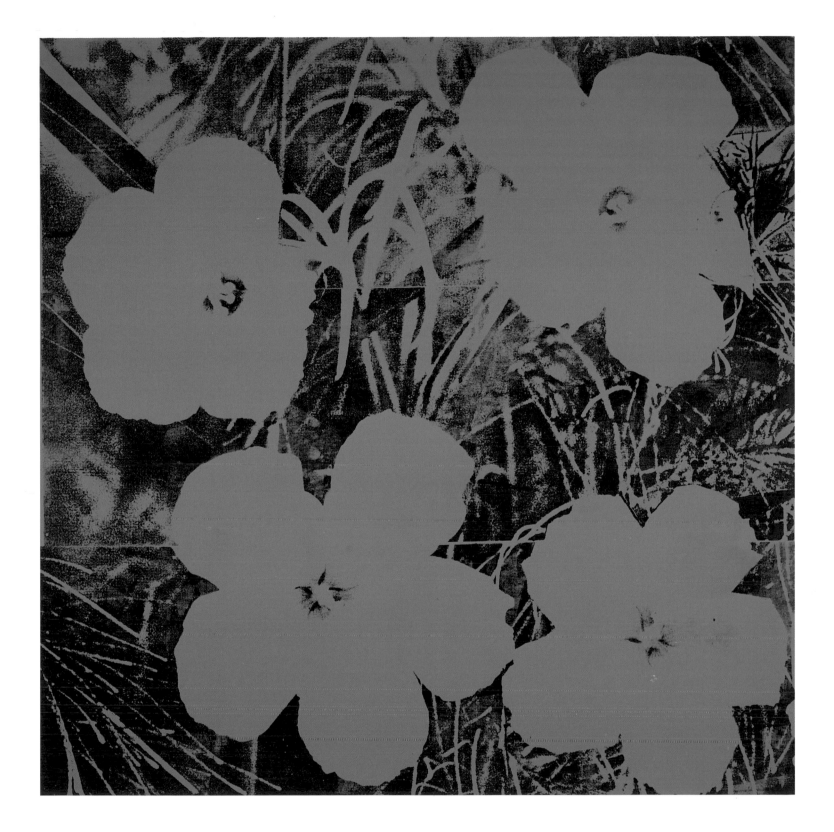

79 **Ten-Foot Flowers** **1967** Private collection, Courtesy Faggionato Fine Arts, London

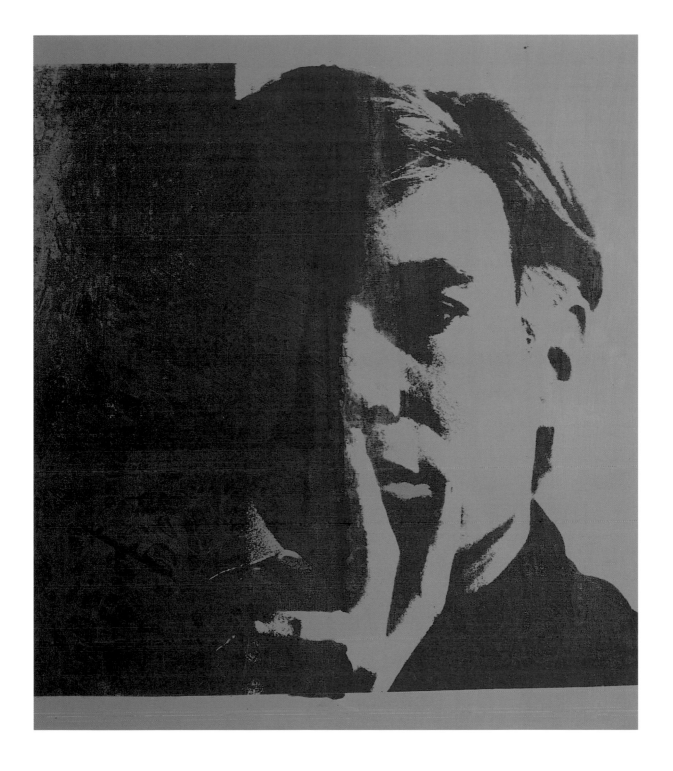

80　**Self-Portrait** 1967　Fondation Beyeler, Riehen/Basle

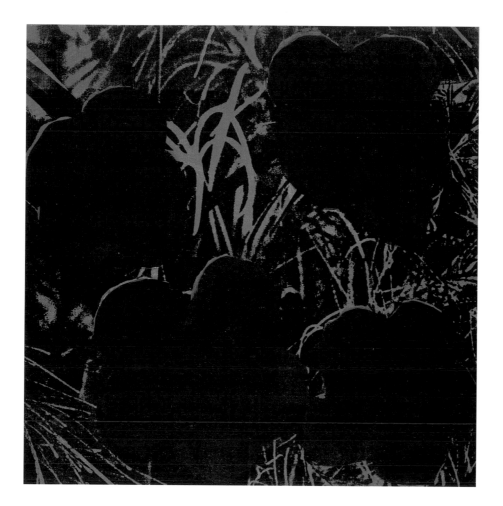

81 **Two-Foot Flowers** **1964** Collection Froehlich, Stuttgart

156

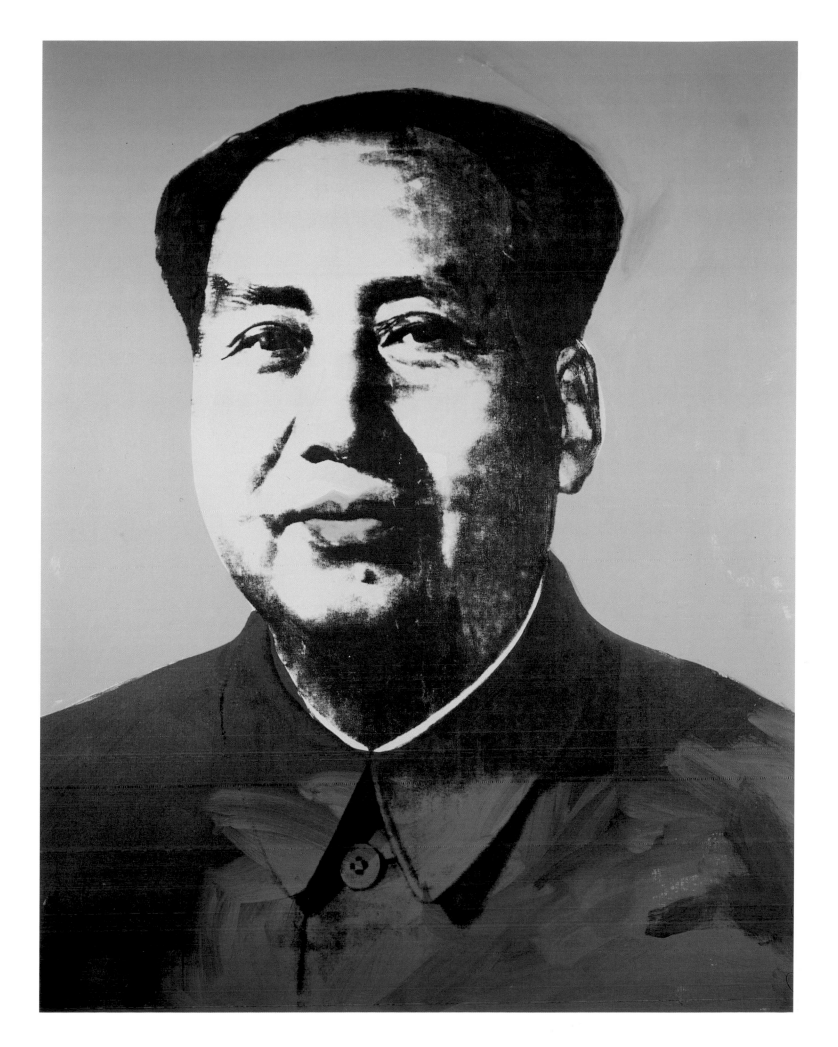

83 **Mao** **1972** Louisiana Museum of Modern Art, Humlebæk, Denmark

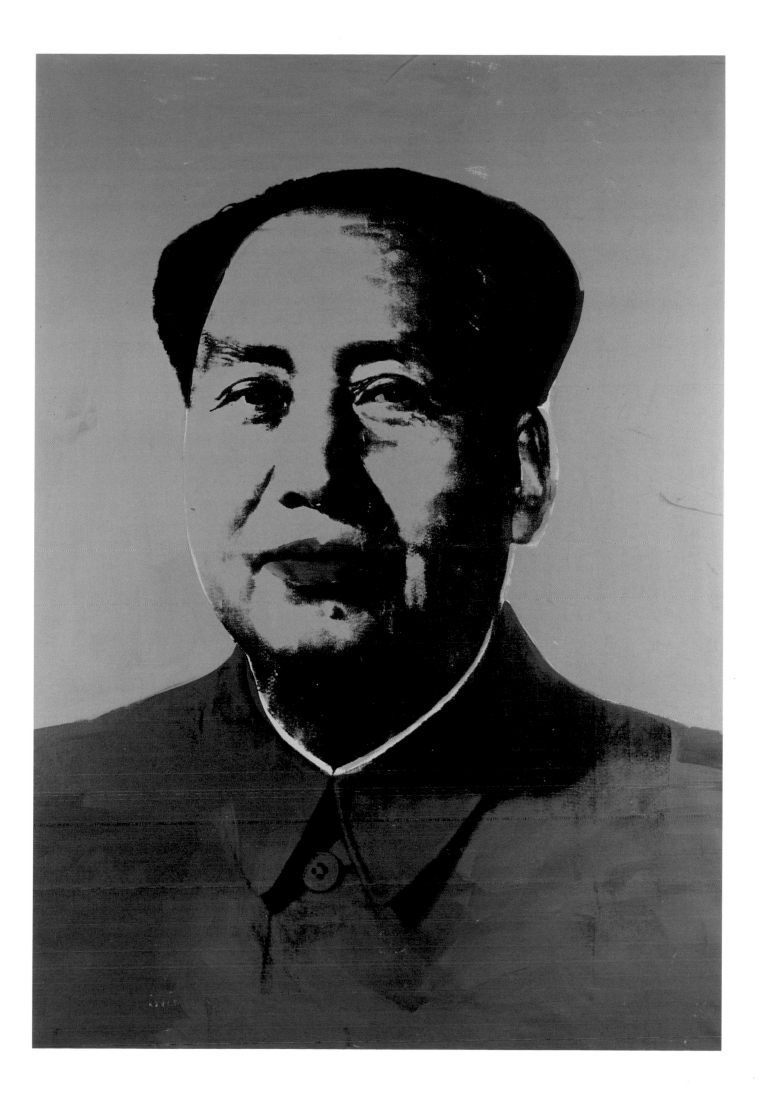

ANDY WARHOL STUDIO 860 BROADWAY

EYES ON THE SQUARE

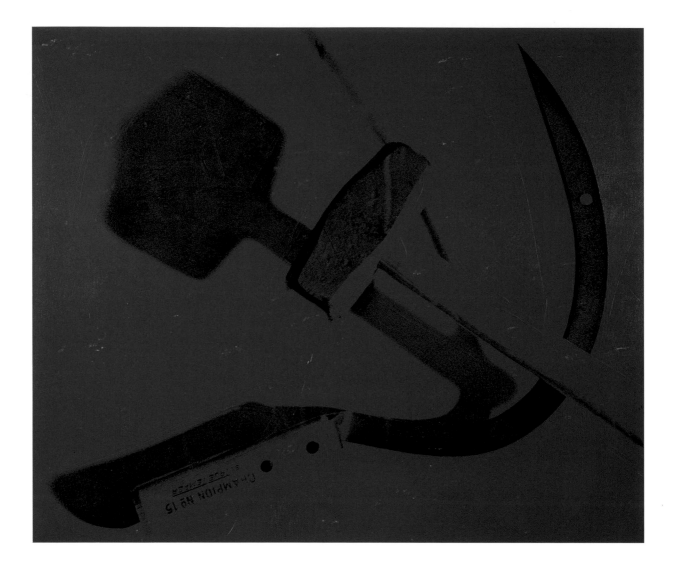

84 **Hammer and Sickle** **1976** Private collection

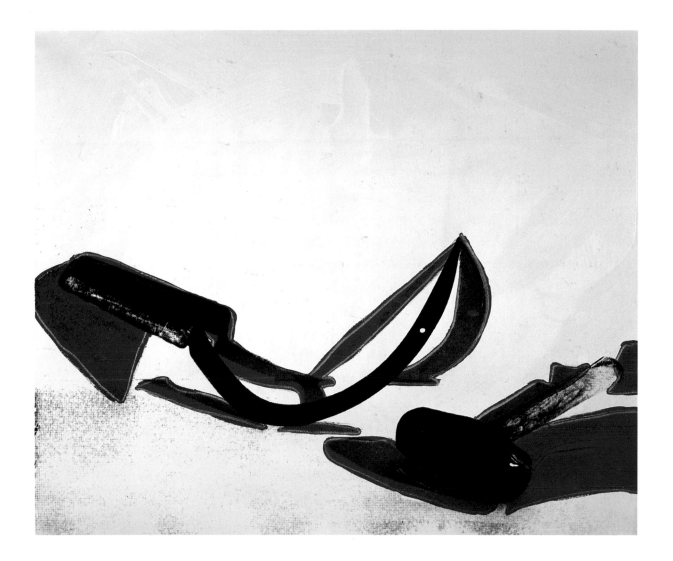

85 Hammer and Sickle 1976 Private collection

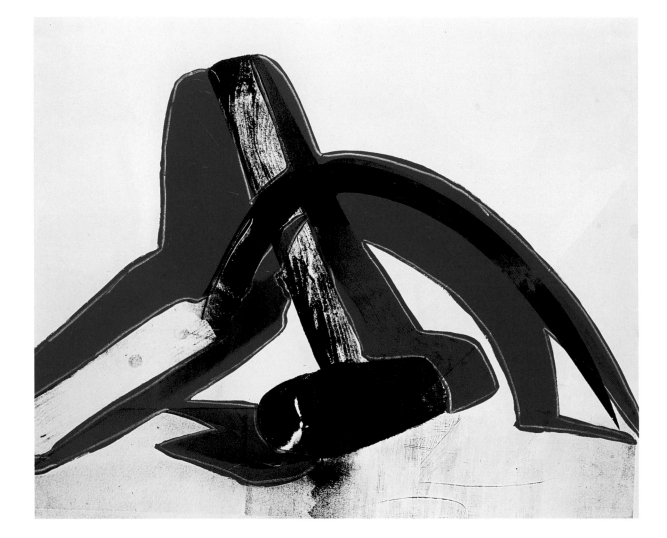

86 Hammer and Sickle 1976 Matthias Brunner, Zurich

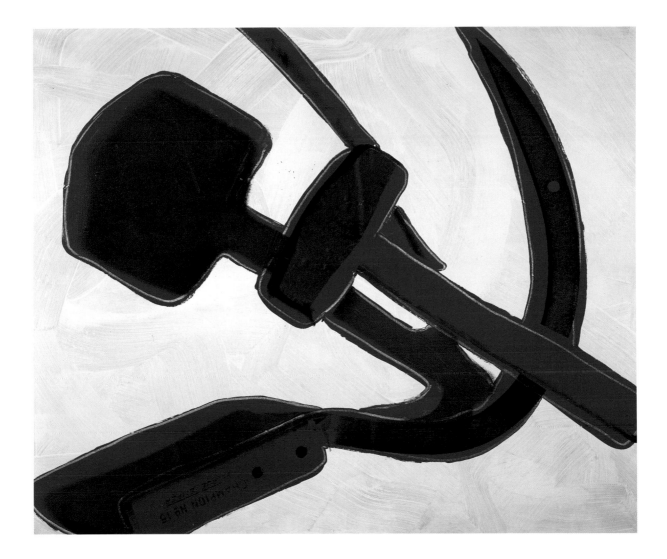

87 **Hammer and Sickle** **1976** Private collection, USA

88 Hammer and Sickle 1976 Private collection

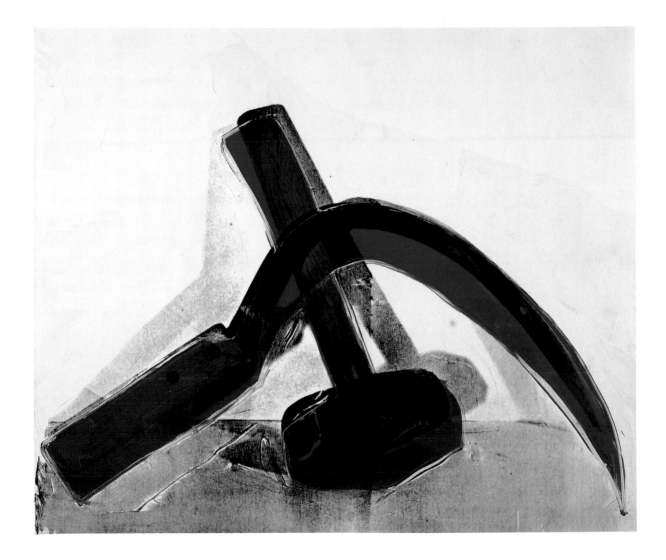

89 **Hammer and Sickle** **1976** Private collection

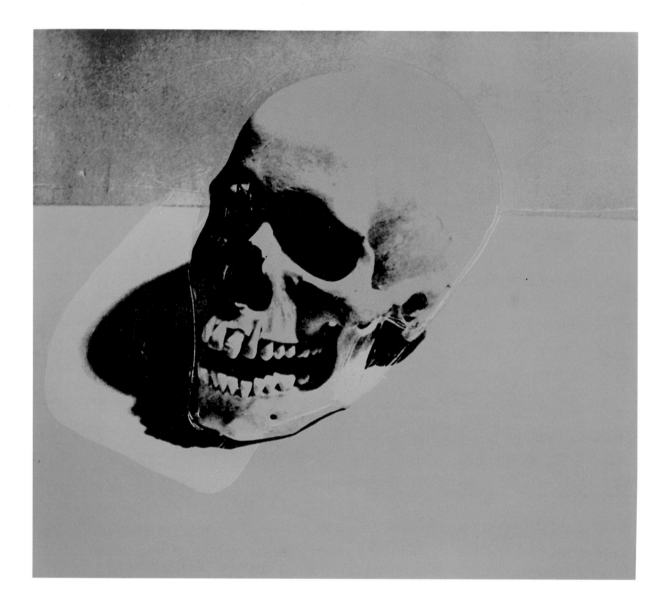

90 Skull 1976 The Andy Warhol Museum, Pittsburgh; Founding Collection, Contribution Dia Center for the Arts

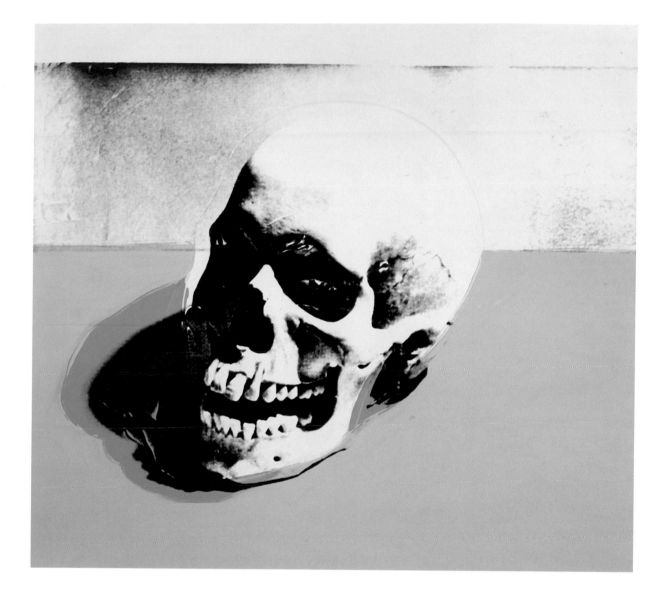

91 Skull 1976 The Andy Warhol Museum, Pittsburgh, Founding Collection, Contribution Dia Center for the Arts

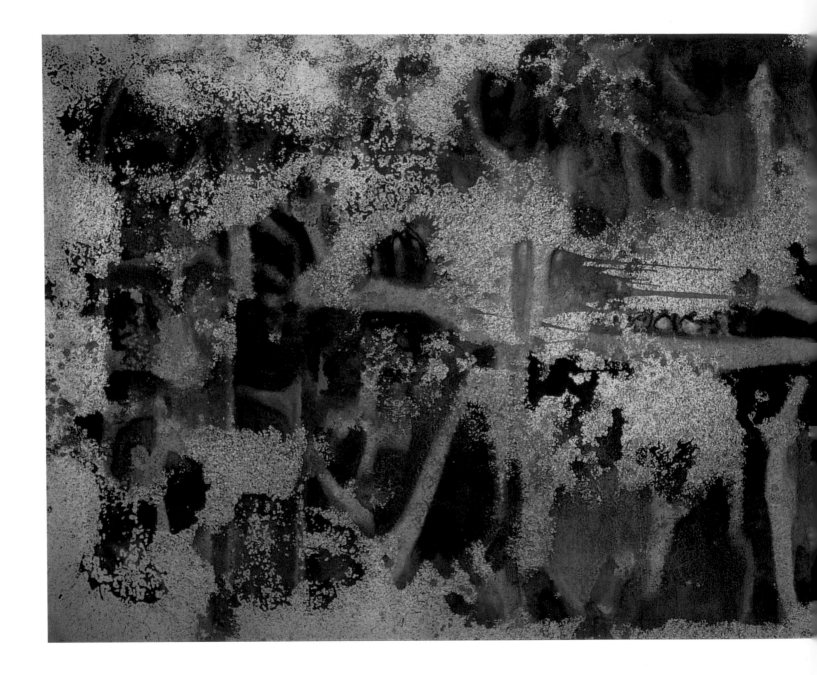

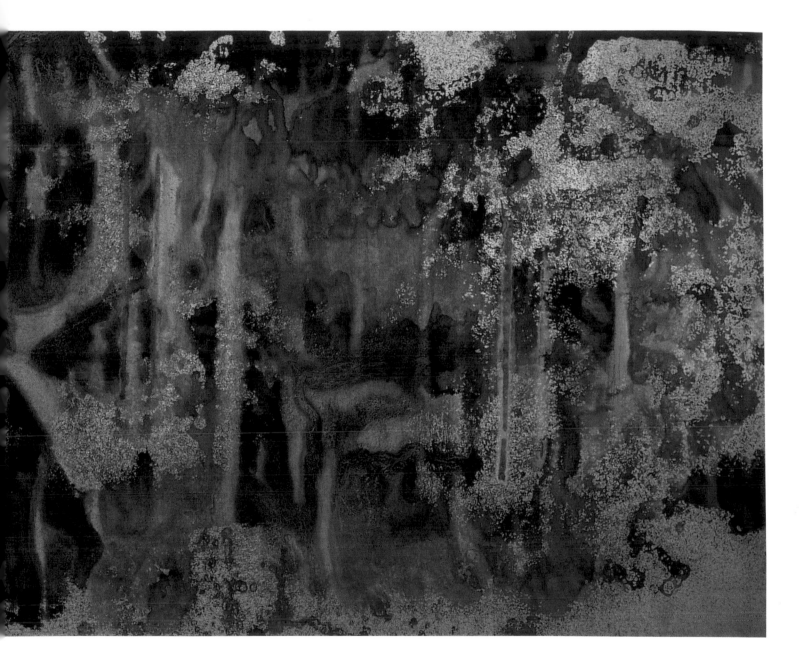

92 **Oxidation Painting 1978** Daros Collection, Switzerland

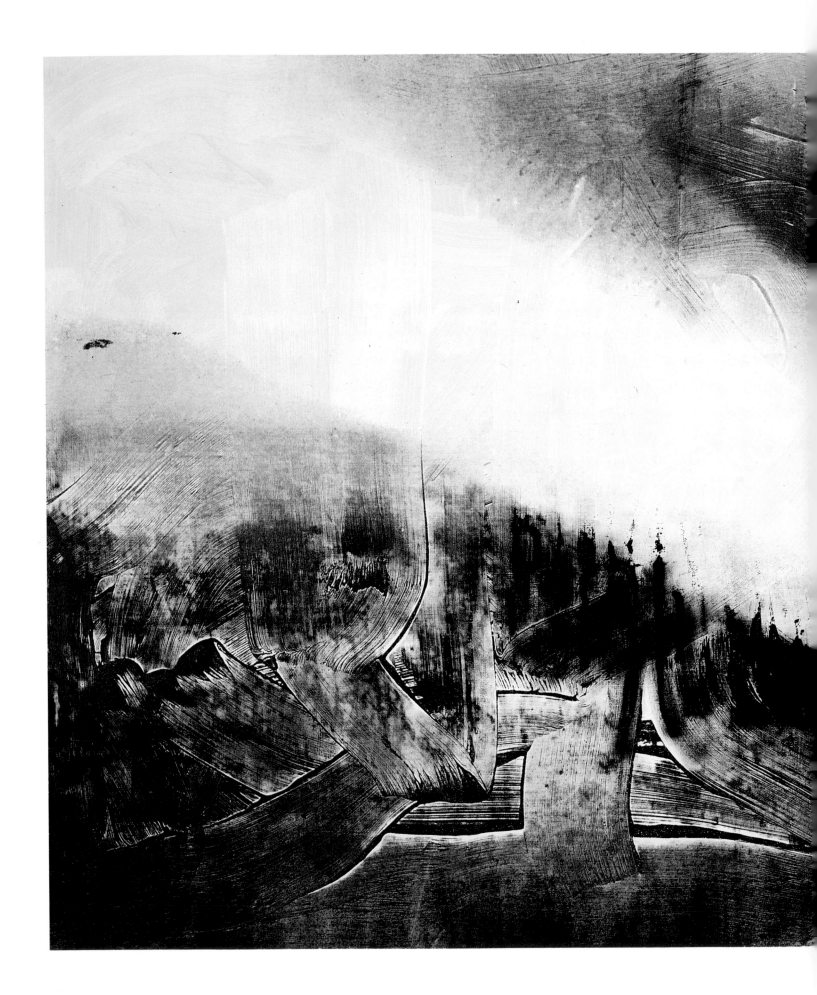

93 **Shadows 1978** Daros Collection, Switzerland

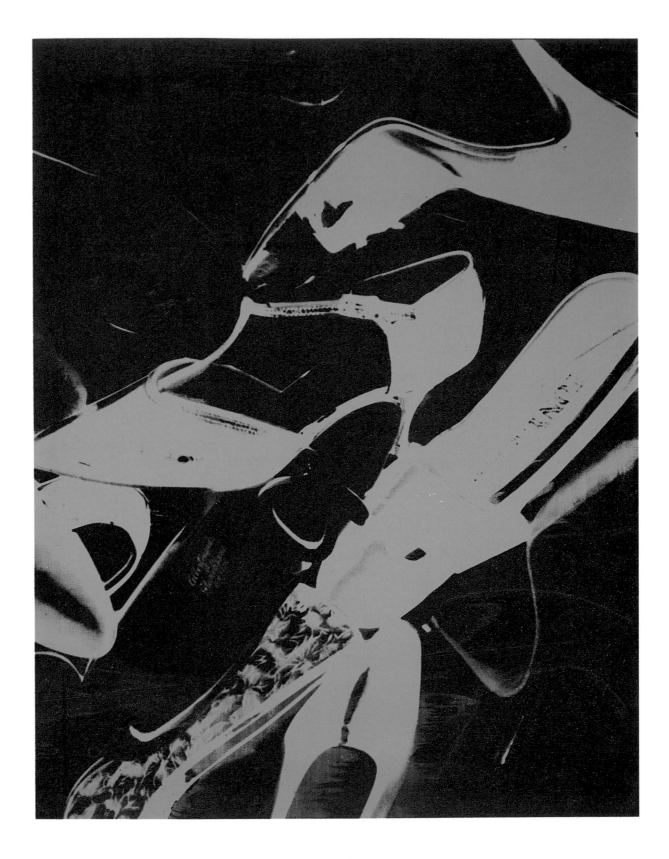

94 **Diamond Dust Shoes** 1980 The Andy Warhol Foundation for the Visual Arts, Inc., New York

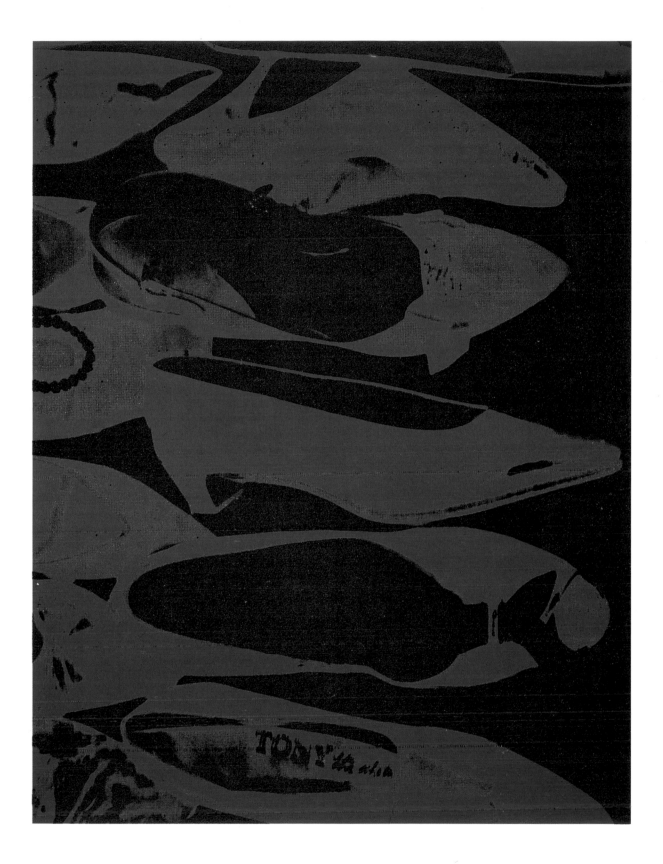

95　**Diamond Dust Shoes**　**1980**　The Andy Warhol Foundation for the Visual Arts, Inc., New York

96 **Diamond Dust Shadows** 1979 Thomas Ammann Fine Art AG, Zurich

97 **Oxidation Painting 1978** Collection Froehlich, Stuttgart

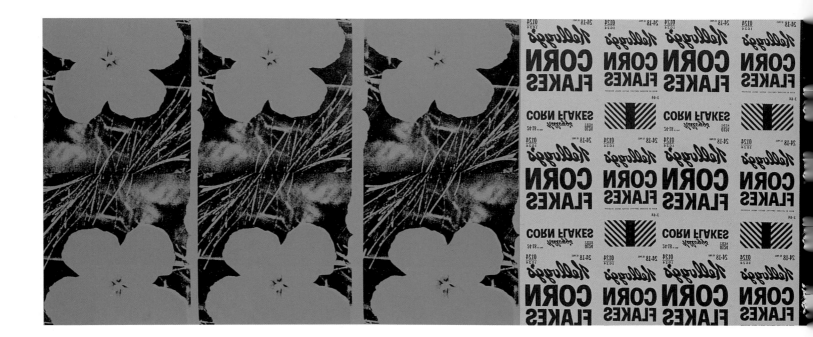

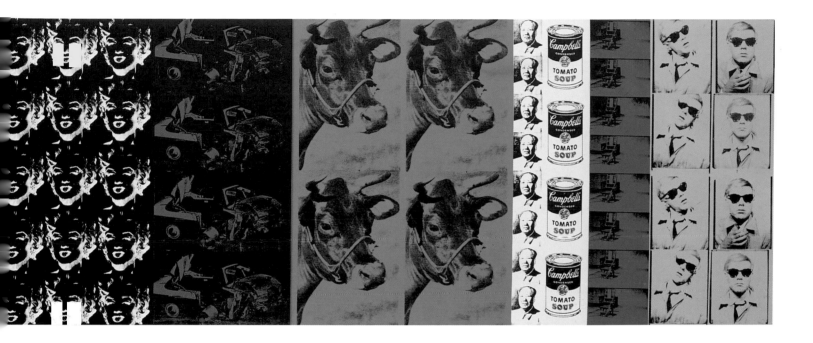

ANDY WARHOL STUDIO 22 EAST 33RD STREET

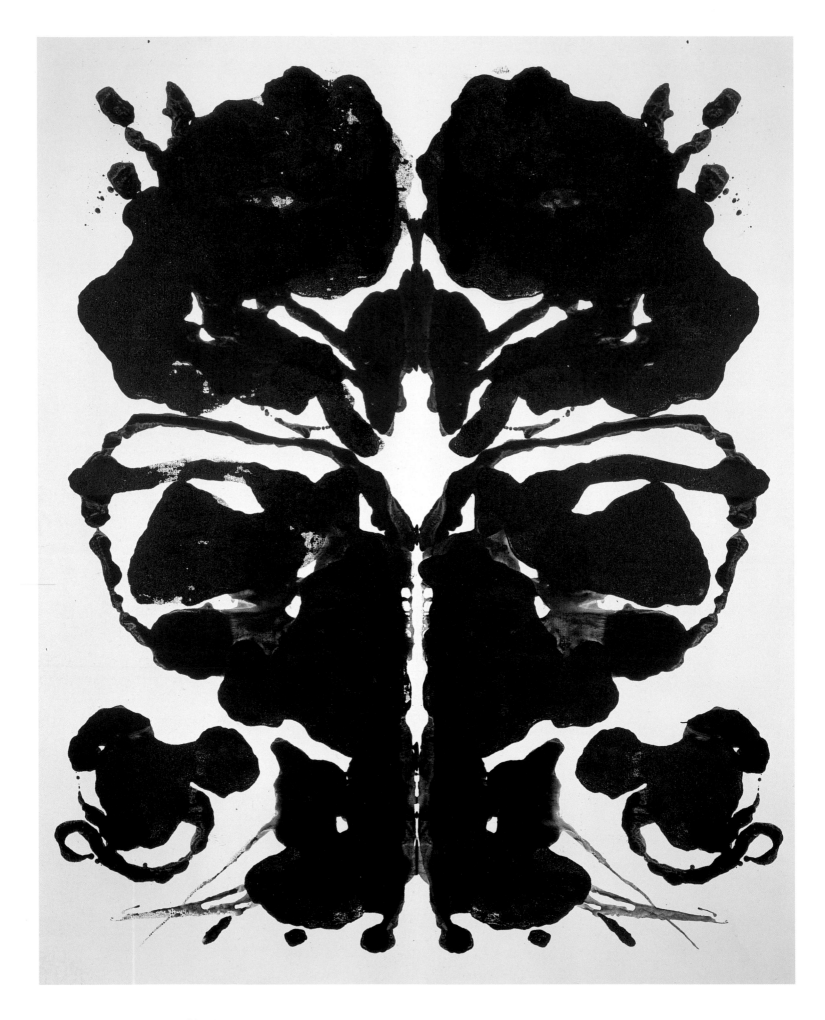

99 Rorschach 1984 Collection of Norah and Norman Stone. Courtesy Thea Westreich Art Advisory Services

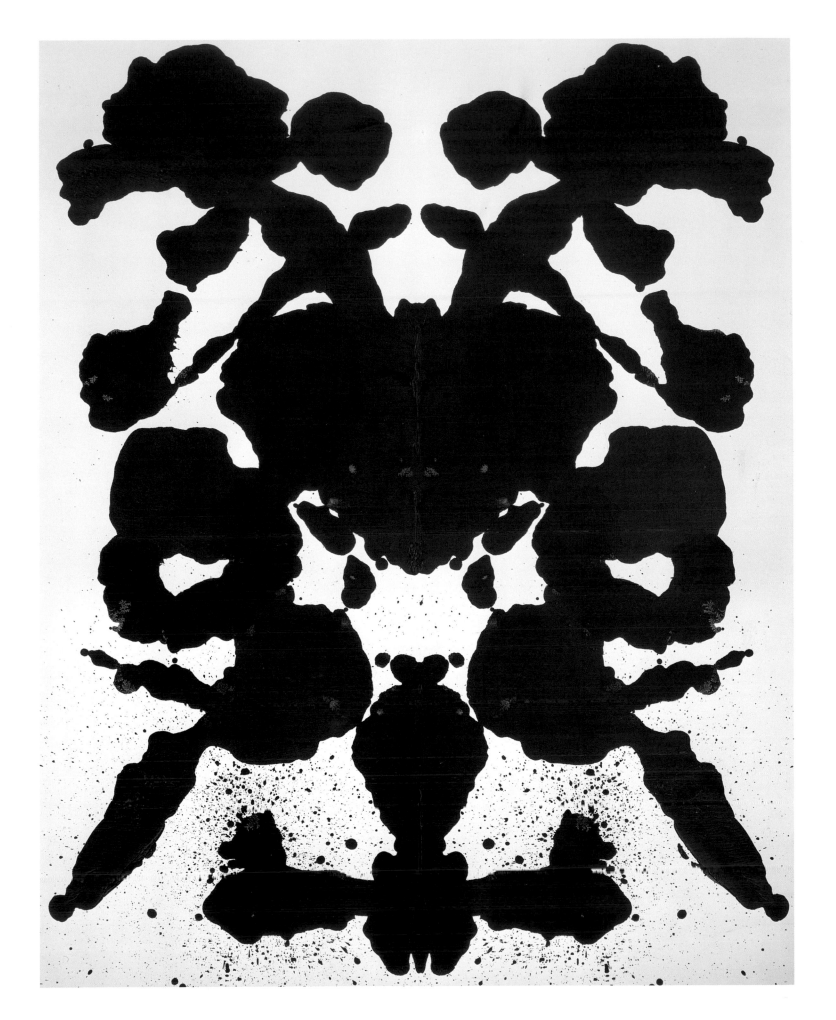

100 **Rorschach** 1984 Collection of Irma and Norman Braman

101 **Camouflage Beuys 1986** Galerie Bernd Klüser, Munich

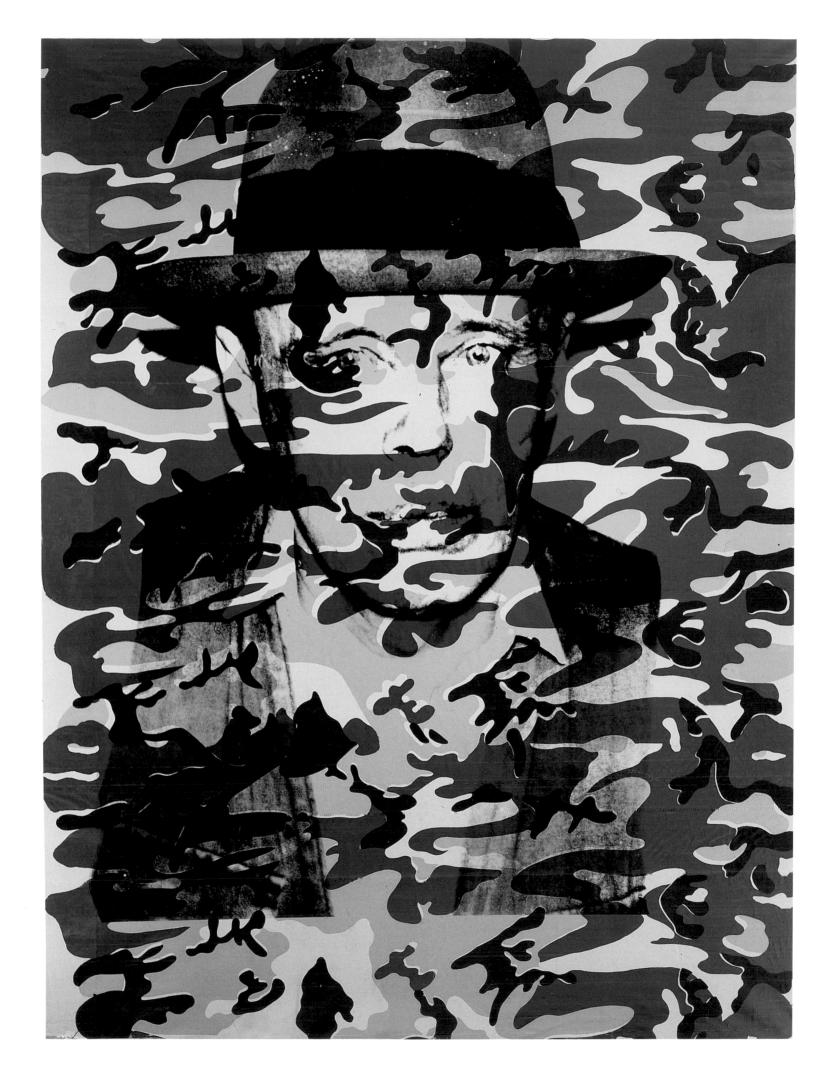

186

102 Joseph Beuys 1986 Courtesy Galerie Beyeler, Basle

103 **Joseph Beuys 1986** Fondation Beyeler, Riehen/Basle

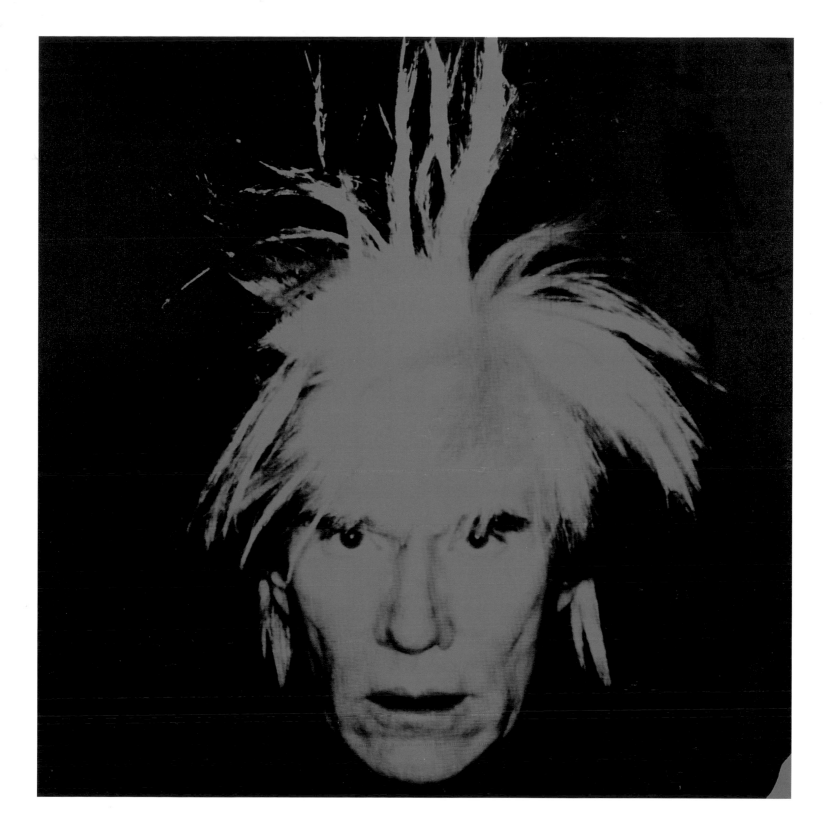

104 **Self-Portrait 1986** Collection Vanhaerents, Torhout, Belgium

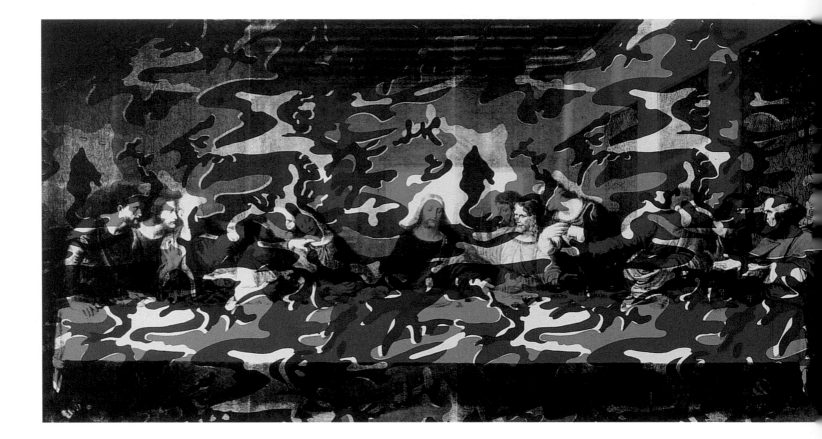

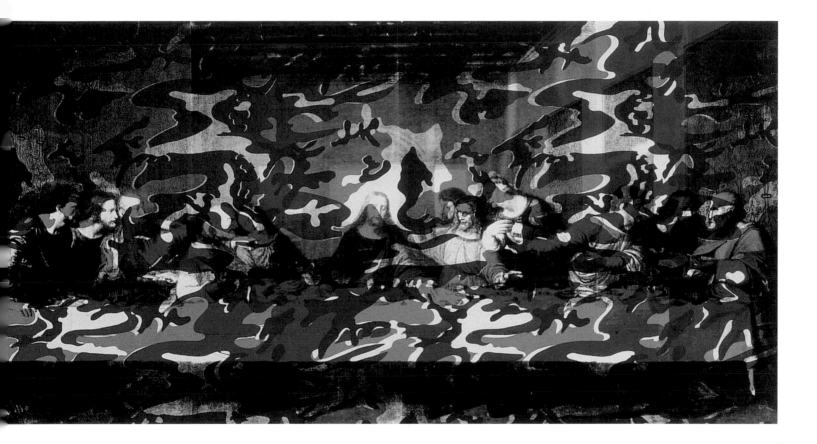

105 Camouflage Last Supper 1986 The Menil Collection, Houston. Gift of The Andy Warhol Foundation for the Visual Arts, Inc.

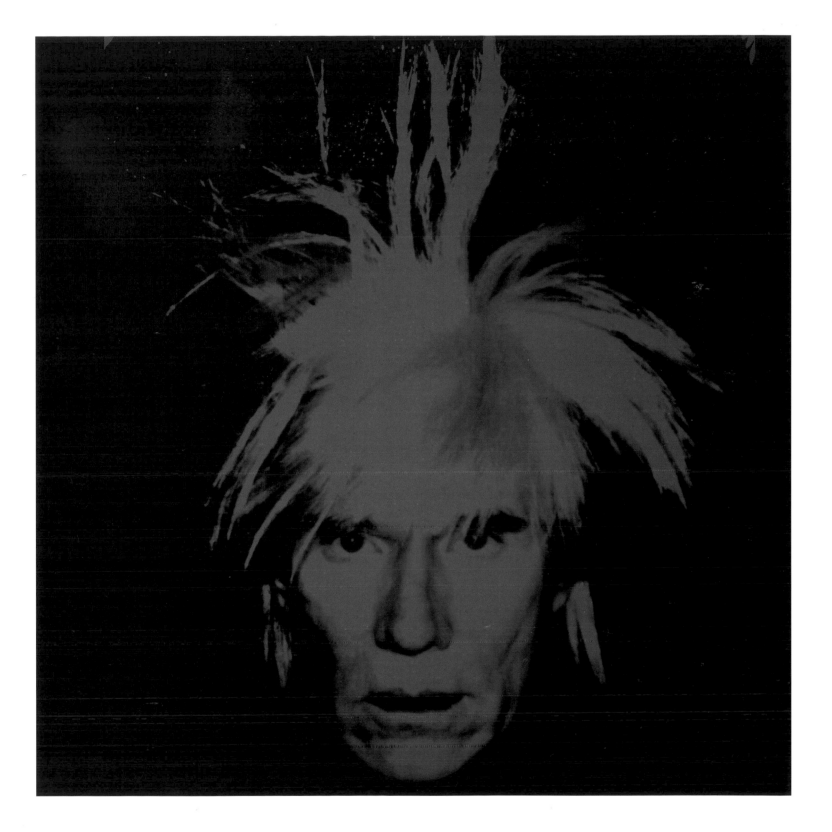

106 **Self-Portrait** **1986** Courtesy Anthony d'Offay Gallery, London

List of Works

* out of exhibition
** out of catalog

1 Superman
1961
Casein and wax crayon on cotton
67 x 52 inches/170.2 x 132.1 cm
Collection Gunter Sachs

2 Popeye
1961
Casein on cotton
68 1/4 x 58 5/8 inches/173.4 x 148.9 cm
Private collection

3 Saturday's Popeye
1961
Casein on cotton
42 1/2 x 39 inches/108 x 99.1 cm
Ludwig Forum für Internationale Kunst,
Collection Ludwig

4 Batman
1961
Casein and wax crayon on linen
28 3/4 x 43 3/4 inches/73 x 111.1 cm
Private collection

5 Dick Tracy
1961
Casein and wax crayon on cotton
48 x 33 3/4 inches/121.9 x 85.7 cm
Courtesy The Brant Foundation, Greenwich, CT

***6 Dick Tracy and Sam Ketchum**
1961
Casein and wax crayon on linen
79 x 52 1/2 inches/200.7 x 133.4 cm
Collection David Geffen, Los Angeles

7 Nancy
1961
Casein on linen
37 1/4 x 43 1/8 inches/94.6 x 109.5 cm
Private collection

8 A Boy for Meg [1]
1961
Casein and wax crayon on linen
66 3/4 x 52 1/2 inches/169.5 x 133.4 cm
Private collection

9 Coca-Cola [1]
1961
Casein, wax crayon, and oil paint on cotton
52 x 40 3/4 inches/132.1 x 103.5 cm
Private collection

10 Coca-Cola [2]
1961
Casein and crayon on linen
69 1/2 x 52 1/4 inches/176.5 x 132.7 cm
The Andy Warhol Museum, Pittsburgh;
Founding Collection, Contribution
Dia Center for the Arts

***11 Before and After [1]**
1961
Casein on cotton
68 x 54 inches/172.7 x 137.2 cm
The Metropolitan Museum of Art, New York.
Gift of Halston, 1981

12 Before and After [3]
1961
Casein on linen
54 x 70 inches/137.2 x 177.8 cm
Private collection, San Francisco

13 Close Cover Before Striking (Pepsi-Cola)
1962
Acrylic, pencil, Letraset, and sandpaper
on linen
72 x 54 inches/182.9 x 137.2 cm
Museum Ludwig, Cologne. Foundation Ludwig,
1976

14 Close Cover Before Striking (Coca-Cola)
1962
Acrylic, pencil, Letraset, and sandpaper
on linen
72 x 54 1/4 inches/182.9 x 137.8 cm
Louisiana Museum of Modern Art, Humlebæk,
Denmark

15 Do It Yourself (Seascape)
1962
Acrylic, pencil, and Letraset on linen
54 1/4 x 72 1/4 inches/137.8 x 183.5 cm
Staatliche Museen zu Berlin, Nationalgalerie,
Collection Marx

***16 Do It Yourself (Flowers)**
1962
Acrylic, pencil, and Letraset on linen
69 x 59 inches/175.3 x 149.9 cm
Daros Collection, Switzerland

17 Do It Yourself (Violin)
1962
Acrylic, pencil, crayon, and Letraset on linen
54 x 72 inches/137.2 x 182.9 cm
Private collection

18 **Do It Yourself (Landscape)**
1962
Acrylic, pencil, and Letraset on linen
69 3/4 x 54 1/8 inches/177.2 x 137.5 cm
Museum Ludwig, Cologne. Foundation Ludwig,
1976

19 **Dance Diagram [4]**
1962
Casein and pencil on linen
70 x 54 inches/177.8 x 137.2 cm
Moderna Museet, Stockholm

20 **Dance Diagram [3]**
1962
Casein on linen
69 3/4 x 54 inches/177.2 x 137.2 cm
Private collection

21 **Dance Diagram [6]**
1962
Casein and pencil on linen
71 1/2 x 53 1/2 inches/181.6 x 135.9 cm
Daros Collection, Switzerland

22 **One Dollar Bill—Silver Certificate**
1962
Casein and pencil on linen
52 1/8 x 71 5/8 inches/132.4 x 181.9 cm
Private collection, Switzerland

23 **Campbell's Soup Can (Scotch Broth)**
1962
Casein and pencil on linen
20 x 16 inches/50.8 x 40.6 cm
Collection Uli Knecht

24 **Big Torn Campbell's Soup Can
(Vegetable Beef)**
1962
Casein, goldpaint, and pencil on linen
72 x 53 1/2 inches/182.9 x 135.9 cm
Kunsthaus Zürich

25 **Big Torn Campbell's Soup Can
(Pepper Pot)**
1962
Casein and pencil on linen
72 x 54 inches/182.9 x 137.2 cm
Private collection, Switzerland

26 **Front and Back Dollar Bills**
1962
Silkscreen ink and pencil on linen
82 3/4 x 19 inches/210.2 x 48.3 cm
(each panel)
Private collection, Switzerland

27 **Campbell's Soup Box**
1962
Casein, pencil, and spraypaint on plywood
22 x 15 3/4 x 15 3/4 inches/
55.9 x 40 x 40 cm
The Andy Warhol Museum, Pittsburgh;
Founding Collection, Contribution The Andy
Warhol Foundation for the Visual Arts, Inc.

28 **100 Cans**
1962
Casein, pencil, and spraypaint on cotton
72 3/8 x 52 3/8 inches/183.8 x 133 cm
Albright-Knox Art Gallery, Buffalo, New York.
Gift of Seymour H. Knox, Jr., 1963

*29 **Green Coca-Cola Bottles**
1962
Silkscreen ink, acrylic, and pencil on linen
82 1/2 x 57 inches/209.6 x 144.8 cm
Whitney Museum of American Art, New York.
Purchase, with funds from the Friends of
the Whitney Museum of American Art

30 **Cherry Marilyn**
1962
Silkscreen ink and acrylic on linen
20 x 16 inches/50.8 x 40.6 cm
Private collection

31 **Lavender Marilyn [2]**
1962
Silkscreen ink and acrylic on linen
20 x 15 7/8 inches/50.8 x 40.3 cm
Collection Uli Knecht

*32 **Warren**
1962
Silkscreen ink and pencil on linen
81 1/2 x 83 inches/207 x 210.8 cm
Private collection

33 **Troy**
1962
Silkscreen ink, acrylic, and pencil on linen
82 1/4 x 82 1/2 inches/208.9 x 209.6 cm
Private collection, Courtesy Massimo Martino
Fine Arts & Projects, Mendrisio

34 **Liz #1**
1963
Silkscreen ink and acrylic on linen
40 x 40 inches/101.6 x 101.6 cm
Sonnabend Collection

35 **Liz #2**
1963
Silkscreen ink and acrylic on linen
40 x 40 inches/101.6 x 101.6 cm
Private collection

36 **Liz #5**
1963
Silkscreen ink and acrylic on linen
40 x 40 inches/101.6 x 101.6 cm
Sonnabend Collection

37 **Liz #3**
1963
Silkscreen ink and acrylic on linen
40 x 40 inches/101.6 x 101.6 cm
Private collection

38 **Single Elvis**
1963
Silkscreen ink and silver paint on linen
82 x 36 inches/208.3 x 91.4 cm
Collection National Gallery of Australia,
Canberra

39 **Single Elvis**
1963
Silkscreen ink, silver paint, spray paint, and
pencil on linen
82 1/16 x 42 inches/208.4 x 106.7 cm
Museum of Contemporary Art –
Ludwig Museum, Budapest

40 Elvis 2 Times
1963
Silkscreen ink and silver paint on linen
84 x 71 1/2 inches/213.4 x 181.6 cm
Private collection, USA

41 Double Elvis
1963
Silkscreen ink and silver paint on linen
82 x 82 inches/208.3 x 208.3 cm
Private collection

42 Silver Liz
1963
Silkscreen ink, acrylic, and spray paint
on linen
40 x 40 inches/101.6 x 101.6 cm (each panel)
Private collection

43 White Disaster
1963
Silkscreen ink and pencil on linen
144 3/4 x 82 7/8 inches/367.7 x 210.5 cm
Private collection

44 Green Car Crash
1962
Silkscreen ink and pencil on linen
84 x 82 inches/213.4 x 208.3 cm
Private collection

45 Green Burning Car I
1963
Silkscreen ink and acrylic on linen
80 x 90 inches/203.2 x 228.6 cm
Private collection

46 Black and White Disaster #4
1963
Silkscreen ink, acrylic, and pencil on linen
103 x 82 1/4 inches/261.6 x 208.9 cm
(each panel)
Öffentliche Kunstsammlung Basel,
Kunstmuseum

47 Bellevue I
1963
Silkscreen ink on linen
106 x 83 inches/269.2 x 210.8 cm
Private collection

48 Orange Car Crash
1963
Silkscreen ink and acrylic on linen
86 1/2 x 82 1/4 inches/
219.7 x 208.9 cm
GAM – Galleria Civica d'Arte Moderna
e Contemporanea, Turin

49 Silver Car Crash
1963
Silkscreen ink and silver paint on linen
103 3/4 x 80 1/4 inches/263.5 x 203.8 cm
Private collection

50 Bellevue II
1963
Silkscreen ink on linen
82 x 82 inches/208.3 x 208.3 cm
Stedelijk Museum Amsterdam

51 Suicide (Purple Jumping Man)
1963
Silkscreen ink and acrylic on linen
90.5 x 79.5 inches/230 x 202 cm
Tehran Museum of Contemporary Art

52 Black and White Disaster
1963
Silkscreen ink and spray paint on linen
96 x 72 inches/243.8 x 182.9 cm
Los Angeles County Museum of Art.
Gift of Leo Castelli Gallery and Ferus Gallery
through the Contemporary Art Council

53 Suicide (Fallen Body)
1963
Silkscreen ink and silver paint on linen
112 x 80 1/4 inches/284.5 x 203.8 cm
Private collection

54 Orange Disaster #5
1963
Silkscreen ink, acrylic, and pencil on linen
106 x 81 3/4 inches/269.2 x 207.6 cm
Solomon R. Guggenheim Museum, New York.
Gift, Harry N. Abrams Family Collection, 1974

55 Gangster Funeral
1963
Silkscreen ink, acrylic, and pencil on linen
105 x 75 5/8 inches/266.7 x 192.1 cm
The Andy Warhol Museum, Pittsburgh;
Founding Collection, Contribution Dia Center
for the Arts

56 Blue Electric Chair
1963
Silkscreen ink and acrylic on linen
104 1/4 x 79 1/4 inches/ 264.8 x 202.3 cm
(each panel)
Private collection

57 Optical Car Crash
1962
Silkscreen ink and pencil on linen
81 7/8 x 82 inches/208 x 208.3 cm
Öffentliche Kunstsammlung Basel,
Kunstmuseum

58 Silver Car Crash
1963
Silkscreen ink and silver paint on linen
105 1/8 x 83 inches/267 x 210.8 cm
(each panel)
Private collection

59 Flowers
1964
Silkscreen ink and acrylic on linen
81 3/4 x 81 1/2 inches/207.6 x 207 cm
Private collection

60 The Week That Was I
1964
Silkscreen ink, acrylic, and spray paint on
linen
80 x 64 inches/203.2 x 162.6 cm
Collection of Samuel and Ronnie Heyman

61 Four-Foot Flowers
1964
Silkscreen ink and acrylic on linen
48 x 48 inches/121.9 x 121.9 cm
The National Museum of Art, Osaka

62 **Red Jackie**
1964
Silkscreen ink and acrylic on linen
40 x 40 inches/101.6 x 101.6 cm
Collection Froehlich, Stuttgart

63 **Twelve Jackies**
1964
Silkscreen ink on linen
80 3/4 x 48 1/4 inches/205.1 x 122.6 cm
Collection Hauser & Wirth, St. Gallen,
Switzerland

64 **Nine Jackies**
1964
Silkscreen ink and acrylic on linen
60 7/8 x 48 3/4 inches/154.6 x 123.8 cm
Sonnabend Collection

65 **Brillo Box, Brillo Box 3c off, Kellogg's
Cornflakes Box, Mott's Apple Juice Box**
1964
Silkscreen ink and house paint on plywood
Brillo Box: 17 x 17 x 14 inches/
43.2 x 43.2 x 35.6 cm; Brillo Box 3c off:
13 3/8 x 16 x 11 1/2 inches/
33.3 x 40.6 x 29.2 cm (each of 5)
Kellogg's Cornflakes Box:
25 x 21 x 17 inches/63.5 x 53.3 x 43.2cm
Mott's Apple Juice Box:
18 x 30 x 22 inches/45.7 x 76.2 x 55.9 cm
Museum für Moderne Kunst, Frankfurt a. M.
Former Collection Ströher, Darmstadt

66 **Brillo Box, Campbell's Tomato Juice Box**
1964
Silkscreen ink and house paint on plywood
Brillo Box: 17 x 17 x 14 inches/
43.2 x 43.2 x 35.6 cm (each of 28)
Campbell's Tomato Juice Box:
10 x 19 x 9 1/2 inches/
25.4 x 48.3 x 24.1 cm (each of 14)
Museum Ludwig, Cologne. Collection Ludwig

67 **Colored Campbell's Soup Can**
1965
Silkscreen ink and spray paint on linen
36 x 24 inches/91.4 x 61 cm
Sonnabend Collection

68 **Colored Campbell's Soup Can**
1965
Silkscreen ink and spray paint on linen
35 3/4 x 24 inches/90.8 x 61 cm
Sonnabend Collection

69 **Colored Campbell's Soup Can**
1965
Silkscreen ink and spray paint on linen
36 x 24 inches/91.4 x 61 cm
Sonnabend Collection

70 **Colored Campbell's Soup Can**
1965
Silkscreen ink on linen
36 x 24 inches/91.4 x 61 cm
Sonnabend Collection

71 **Flowers**
1964
Silkscreen ink, acrylic, and pencil on linen
81 3/4 x 81 3/4 inches/207.6 x 207.6 cm
Hirshhorn Museum and Sculpture Garden,
Smithsonian Institution, Washington, D.C.,
Joseph H. Hirshhorn Bequest, 1981

72 **Shot Sage Blue Marilyn**
1964
Silkscreen ink and acrylic on linen
40 x 40 inches/101.6 x 101.6 cm
Private collection

73 **Shot Light Blue Marilyn**
1964
Silkscreen ink and acrylic on linen
40 x 40 inches/101.6 x 101.6 cm
Courtesy The Brant Foundation,
Greenwich, CT

74 **Turquoise Marilyn**
1964
Silkscreen ink and acrylic on linen
40 x 40 inches/101.6 x 101.6 cm
Stefan T. Edlis Collection

*75 **Shot Orange Marilyn**
1964
Silkscreen ink and acrylic on linen
40 x 40 inches/101.6 x 101.6 cm
Private collection

76 **Shot Red Marilyn**
1964
Silkscreen ink and acrylic on linen
40 x 40 inches/101.6 x 101.6 cm
Private collection

77 **Flowers**
1964
Silkscreen ink and spray paint on linen
81 3/4 x 81 3/4 inches/207.6 x 207.6 cm
Fondation Beyeler, Riehen/Basle

78 **Double Self-Portrait**
1967
Silkscreen ink and acrylic on linen
72 x 72 inches/182.9 x 182.9 cm
(each panel)
The Detroit Institute of Arts, Founders Society
Purchase, Friends of Modern Art Fund

79 **Ten-Foot Flowers**
1967
Silkscreen ink and acrylic on linen
115 x 115 inches/292.1 x 292.1 cm
Private collection, Courtesy Faggionato Fine
Arts, London

80 **Self-Portrait**
1967
Silkscreen ink and acrylic on linen
79 x 70 inches/200.7 x 177.8 cm
Fondation Beyeler, Riehen/Basle

81 **Two-Foot Flowers**
1964
Silkscreen ink and acrylic on linen
24 x 24 inches/61 x 61 cm
Collection Froehlich, Stuttgart

82 **Mao**
1972
Silkscreen ink and acrylic on linen
82 x 61 inches/208.3 x 154.9 cm
Daros Collection, Switzerland

83 **Hammer and Sickle**
1976
Silkscreen ink, acrylic, and pencil on linen
72 x 86 inches/183 x 218.5 cm
Private collection

84 **Hammer and Sickle**
1976
Silkscreen ink, acrylic, and pencil on linen
72 x 86 inches/183 x 218.5 cm
Private collection

85 **Hammer and Sickle**
1976
Silkscreen ink, acrylic, and pencil on linen
72 x 86 inches/183 x 218.5 cm
Matthias Brunner, Zurich

86 **Hammer and Sickle**
1976
Silkscreen ink, acrylic, and pencil on linen
72 x 86 inches/183 x 218.5 cm
Private collection, USA

87 **Hammer and Sickle**
1976
Silkscreen ink, acrylic, and pencil on linen
72 x 86 inches/183 x 218.5 cm
Private collection

88 **Hammer and Sickle**
1976
Silkscreen ink, acrylic, and pencil on linen
72 x 86 inches/183 x 218.5 cm
Private collection

** **Hammer and Sickle**
1976
Silkscreen ink, acrylic, and pencil on linen
72 x 86 inches/183 x 218.5 cm
Thomas Ammann Fine Art AG, Zurich

89 **Mao**
1972
Silkscreen ink and acrylic on linen
82 x 64 inches/208.3 x 162.5 cm
Louisiana Museum of Modern Art, Humlebæk,
Denmark

90 **Skull**
1976
Silkscreen ink and acrylic on linen
72 x 80 inches/183 x 203.2 cm
The Andy Warhol Museum, Pittsburgh;
Founding Collection, Contribution
Dia Center for the Arts

91 **Skull**
1976
Silkscreen ink and acrylic on linen
72 x 80 inches/183 x 203.2 cm
The Andy Warhol Museum, Pittsburgh;
Founding Collection, Contribution
Dia Center for the Arts

92 **Oxidation Painting**
1978
Mixed media on copper metallic paint
on linen
78 x 204 1/2 inches/198 x 519.5 cm
Daros Collection, Switzerland

93 **Shadows**
1978
Silkscreen ink and acrylic on linen
78 x 138 inches/198 x 351 cm
Daros Collection, Switzerland

94 **Diamond Dust Shoes**
1980
Silkscreen ink, acrylic, and diamond dust
on linen
90 x 70 inches/228 x 177.8 cm
The Andy Warhol Foundation for the Visual
Arts, Inc., New York

95 **Diamond Dust Shoes**
1980
Silkscreen ink, acrylic, and diamond dust
on linen
90 x 70 inches/228 x 177.8 cm
The Andy Warhol Foundation for the Visual
Arts, Inc., New York

** **Diamond Dust Shoes**
1980
Silkscreen ink, acrylic, and diamond dust
on linen
90 x 70 inches/228 x 177.8 cm
The Andy Warhol Foundation for the Visual
Arts, Inc., New York

96 **Diamond Dust Shadows**
1979
Acrylic and diamond dust on linen
76 x 52 inches/193 x 132 cm
Thomas Ammann Fine Art AG, Zurich

** **Diamond Dust Shadows**
1979
Acrylic and diamond dust on linen
76 x 52 inches/193 x 132 cm
Thomas Ammann Fine Art AG, Zurich

** **Diamond Dust Shadows**
1979
Acrylic and diamond dust on linen
76 x 52 inches/193 x 132 cm
Thomas Ammann Fine Art AG, Zurich

97 **Oxidation Painting**
1978
Mixed media on copper metallic paint on
linen
76 x 52 inches/193 x 132.1 cm
Collection Froehlich, Stuttgart

98 **Big Retrospective**
1979
Silkscreen ink and acrylic on linen
81 1/2 x 425 1/2 inches/207 x 1079.8 cm
Courtesy Galerie Bruno Bischofberger, Zurich

99 **Rorschach**
1984
Acrylic on linen
120 x 96 inches/304.8 x 244.8 cm
Collection of Norah and Norman Stone.
Courtesy Thea Westreich
Art Advisory Services

100 **Rorschach**
1984
Acrylic on linen
94 1/4 x 76 inches/239 x 193 cm
Collection Irma and Norman Braman

101 **Camouflage Beuys**
1986
Silkscreen ink and acrylic on linen
111 1/2 x 83 inches/283.2 x 210.8 cm
Galerie Bernd Klüser, Munich

102 **Joseph Beuys**
1986
Silkscreen ink, acrylic, and diamond dust
on linen
40 x 40 inches/101.6 x 101.6 cm
Courtesy Galerie Beyeler, Basle

103 **Joseph Beuys**
1986
Silkscreen ink, acrylic, and diamond dust
on linen
40 x 40 inches/101.6 x 101.6 cm
Fondation Beyeler, Riehen/Basle

104 **Self-Portrait**
1986
Silkscreen ink and acrylic on linen
80 x 80 inches/203.2 x 203.2 cm
Collection Vanhaerents, Torhout, Belgium

*105 **Camouflage Last Supper**
1986
Silkscreen ink and acrylic on linen
78 x 306 inches/198.1 x 777.2 cm
The Menil Collection, Houston. Gift of
The Andy Warhol Foundation for the
Visual Arts, Inc.

106 **Self-Portrait**
1986
Silkscreen ink and acrylic on linen
108 x 108 inches/274.3 x 274.3 cm
Courtesy Anthony d'Offay Gallery, London

Biography

1928

Born on 6 August as Andrew Warhola in Pitts-
burgh. His parents Andrej and Julia come from
Miková, near Medzilaborce, Slovakia (formerly
Czechoslovakia). Has two older brothers: Paul,
born in 1922, and John, born in 1925.
"I'd prefer to remain a mystery."[1]

1934–45

Grammar and high school.
Summer of 1936: Suffers from St. Vitus's
dance.
Paints and draws, takes pictures with a Kodak
Brownie camera and collects the autographs
of film stars.
1942: Death of his father.
"I never like to give my background and,
anyway, I make it all up different every time
I'm asked."[1]

1945–49

Studies at the Carnegie Institute of Technol-
ogy in Pittsburgh, Department of Painting and
Design.
1946: Receives the 'Martin B. Leisser Prize'
for his drawings exhibited at the Carnegie's
Fine Arts Gallery.

1947: Begins to experiment with the so-called
'blotted-line' technique: the contours of an
existing drawing are traced with ink and then
printed on a second sheet. This technique
becomes the trade mark of his work as a
commercial artist in the 1950s.
1949: Moves to New York.
Andrew Warhola becomes Andy Warhol.
"The Empire State Building is a Star."[3]

1950

Is in great demand as a graphic artist by fash-
ion magazines like *Mademoiselle*, *Glamour*,
etc.
"Life and living influence me more than parti-
cular people."[1]

1951

Is awarded first prize for newspaper adver-
tisement for the CBS radio show "The Nation's
Nightmare." During the 1950s he receives
numerous prizes from the Art Directors' Club
and from the American Institute of Graphic
Arts.
"I was doing very well as a commercial
artist…"[1]

1952

First individual exhibition (*Fifteen Drawings Based on the Writings of Truman Capote*) at the Hugo Gallery in New York (16 June– 3 July).

Illustrates *Amy Vanderbilt's Complete Book of Etiquette*.

His mother moves to New York and shares an apartment with him and a number of cats.

"…in fact, I was doing better there than with the paintings and movies which haven't done anything."[1]

1953

Produces the books *A is an Alphabet* and *Love is a Pink Cake*. Designs sets for the Theatre 12.

Begins wearing a toupee.

"It didn't surprise me when I made it; it's just work… it's just work."[1]

1954

First group exhibition at the Loft Gallery, New York; shows marbleized papers.

Produces the book *25 Cats Name Sam and One Blue Pussy*.

Is a regular at the Café Serendipity, the "in" place for the commercial art and fashion world.

"I never thought about becoming famous, it doesn't matter."[1]

1955

Begins his successful shoe advertisements for the I. Miller company.

Produces the book *A la Recherche du Shoe Perdu*.

Nathan Gluck becomes his assistant in his activities as a commercial artist.

"I feel exactly the same way now I did before."[1]

1956

Individual exhibitions at the Bodley Gallery, New York: *Studies for a Boy Book* (14 Feb.–3 March) and *Golden Slipper Show or Shoes Shoe in America* (3–22 Dec.).

Produces the book *In the Bottom of My Garden*, designs Christmas cards for Tiffany's, and goes on a trip around the world with Charles Lisanby.

"The world fascinates me. It's so nice, whatever it is."[1]

1957

A Show of Golden Pictures at the Bodley Gallery, New York (2–24 Dec.).

Produces the books, *A Gold Book* and *Holy Cats by Andy Warhol's Mother*.

Founds Andy Warhol Enterprises, Inc.

Has his nose corrected by a plastic surgeon.

"I approve of what everybody does; it must be right because somebody said it was right."[1]

1959

Produces the fantasy cookbook *Wild Raspberries* along with Suzie Frankfurt.

Meets the filmmaker Emile de Antonio who introduces him to the art scene.

"I don't worry about art or life."[1]

1960

In September, he moves to a townhouse at 1342 Lexington Avenue that becomes a center for his work as both a commercial artist and an artist.

"I never wanted to be a painter. I wanted to be a tap-dancer."[1]

1961

Begins to paint pictures using motifs from comics and consumer goods.

Advertisement, *Little King*, *Superman*, *Before and After*, and *Saturday's Popeye* are shown for one week in April at Bonwit Teller.

In autumn the first pictures of the *Campbell's Soup Can* series are created.

"I think of myself as an American artist. I like it here. I think it's so great. It's fantastic."[1]

1962

In the first half of the year, *Dance Diagram*, *Do It Yourself*, *Close Cover Before Striking*, and the serial works *Campbell's Soup Cans*, *Coca-Cola Bottles*, *Airmail Stamps*, and *S & H Stamps* are created.

The *Dollar Bills* are the first pictures that are created by silkscreen.

Lawrence Alloway borrows slides of the *Campbell's Soup Cans*, which he shows at Bennington College.

Thirty-two large-format soup can pictures are shown at the Ferus Gallery in Los Angeles (9 July–4 Aug.)

Summer: Begins to work with photo-silkscreening, produces portraits of Troy Donahue, Natalie Wood, Tab Hunter, and Warren Beatty. After Marilyn Monroe's death (5 Aug.) he begins his first *Marilyn* series.

First portraits of Elvis Presley, Robert Rauschenberg, and Elizabeth Taylor are created.

First individual exhibit in New York at the Stable Gallery (6–24 Nov.) in which an overview of his hand-painted pictures and photo-silkscreens are shown.

Labor Day: He rents the 'Firehouse' on East 87th Street as a space solely for working.

Begins working on the large-scale *Disaster* pictures, *Suicide*, *Car Crash*, the 3-D effect pictures *Optical Car Crash*, *Statue of Liberty*, *Mat Queen*, *Mona Lisa*, and *Merce Cunningham*.

"It was Christmas or Labor day—a holiday—and every time you turned on the radio, they said something like '4 million are going to die.' That started it. But when you see a gruesome picture over and over again, it doesn't really have any effect."[2]

1963

Creation of *Burning Cars*, the serial *Electric Chairs*, *Race Riots*, *Tunafish Disaster,* and the 'silver stars' *Liz* and *Elvis*.

Purchase of a 16 mm camera.

Films (selection): *Tarzan and Jane Regained… Sort of*, *Kiss*, *Sleep*, *Eat*, *Blow Job*.

The poet Gerard Malanga becomes his new assistant.

His first commissioned work is a *Self-Portrait* from Florence Barron.

In the autumn, the portraits of Ethel Scull, Bobby Short and Judith Green are completed, as well as the small format *5 Deaths* and the later *Disaster* pictures, including *Ambulance Disaster*, *Saturday Disaster,* and *Foot and Tire*. Ferus Gallery, Los Angeles: *Elvis* and *Liz* portraits (30 Sept.–30 Oct.).

Meets the underground filmmaker Jonas Mekas. Exchanges his toupee for a silver wig. "I started those (Elizabeth Taylors) a long time ago, when she was so sick and everybody said she was going to die. Now I'm doing them all over, putting bright colors on her lips and eyes."[2]

1964

January: Moves to the new studio on 231 East 47th Street. The now famous Silver Factory that was covered with aluminum foil by Billy Name becomes the production site for the silkscreens, a film studio, a rehearsal stage for The Velvet Underground, a 'living room' for artists and freaks, as well as Billy Name's home.

Thirteen Most Wanted Men, a work commissioned by Philip Johnson for the facade of the New York State Pavilion at the New York World's Fair is painted-over for personal and political reasons.

The *Box* sculptures are shown at the Stable Gallery (21 April–9 May).

Begins the *Jackie* series, portraits of Mike and Bob Abrams, Judy Heiman, the *Self-Portraits* and the commissioned work *Watson Powell, the American Male*.

A visitor to the factory, Dorothy Podber, shoots at the four versions of *Marilyn*, which are later called the *Shot Marilyns*.

The *Flowers* series is shown at the Leo Castelli Gallery (21 Nov.–17 Dec.), makes the small *Electric Chairs* and the small *Race Riots*.

Purchases a tape recorder that becomes his constant companion ("It's my wife").

Shows his *Disaster* series and *Death in America* at the Sonnabend Galerie in Paris (Jan.–Feb.).

Films (selection): *Empire*, *Henry Geldzahler*, *Couch*.

Receives the Independent Film Award from Film Culture.

"I think we are a vacuum here at the Factory, it's great. I like being a vacuum, it leaves me alone to work."[1]

1965

Creation of the series of large color *Campbell's Soup Cans*, the portraits of Florence Barron and Miriam Davidson. Films (selection): *Screen Test #1*, *Screen Test #2*, *The Life of Juanita Castro*, *Kitchen*, *My Hustler*, *Camp*.

First experiments with video.

Designs the cover of a January issue of *Time* magazine.

During the opening of the *Flowers* exhibition at the Sonnabend Galerie in Paris (May), he announces that he is going to give up painting and dedicate himself fully to film.

First major retrospective at the Institute of Contemporary Art, University of Pennsylvania, Philadelphia (8 Oct.–21 Nov.).

Paul Morrissey becomes his director of film production and Edie Sedgwick his 'alter ego'. The Factory party, "The Fifty Most Beautiful People", is also attended by Hollywood celebrities such as Judy Garland.

"If you want to know all about Andy Warhol, just look at the surface of my paintings and films and me, and there I am. There's nothing behind it."[1]

1966

Exhibits *Cow Wallpaper* and *Silver Pillows* at the Leo Castelli Gallery (2–27 April).

Begins *Marlon Brando*, the *Torsos*, the portraits of Holly Solomon and Frances Lewis as well as the *Self-Portraits*.

Produces the first album by The Velvet Underground and Nico as well as the multimedia spectacular *Exploding Plastic Inevitable*.

Films (selection): *The Velvet Underground and Nico*, *The Chelsea Girls*.

Retrospective at the Institute of Contemporary Art, Boston (1 Oct.–6 Nov.). Max's Kansas City, near Union Square, becomes the favorite restaurant of the Factory crowd.

"I don't paint anymore, I gave it up about a year ago and just do movies now. I could do two things at the same time but movies are more exciting."[1]

1967

The big *Self-Portraits* are shown in the American pavilion at Expo '67 in Montreal.

Begins the commissioned portraits of Sidney Janis and Nelson Rockefeller, *Ten Foot Flowers* and *Big Electric Chairs*.

Films (selection): *The Loves of Ondine*, *Bike Boy*, *Lonesome Cowboys*.

Publishes *Andy Warhol's Index (Book)* and *Screen Tests/A Diary*.

Embarks on a college lecture series with members of the Factory and the Andy Warhol imitator, Allen Midgette.

Fred Hughes becomes his exclusive agent and business manager.

"I don't like to touch things… that's why my work is so distant from myself…"[1]

1968

February: Moves to a new studio at 33 Union Square West: a white-painted loft that covers the entire 6th floor.

Begins portraits of Happy Rockefeller and Lita Hornick.

Films: *Blue Movie*, produces *Flesh* under the direction of Paul Morrissey, to whom he leaves more and more of the film work.

First European museum exhibition at the Moderna Museet, Stockholm (10 Feb.–17 March).

3 June: He is shot and seriously wounded by Valerie Solanis, the founder and only member of S.C.U.M. (Society for Cutting Up Men) and is hospitalized for two months.

Publishes the book *a, a Novel,* a transcript of his tape recordings.

Merce Cunningham uses *Silver Clouds* as a backdrop for his ballet *Rain Forest*.

"Everyone could sort of sense that the move

downtown was more than just a change of place. For one thing, the Silver Period was definitely over, we were into white now."[4]

1969

Begins the portraits of Dominique de Menil and Jermaine MacAgy.
The first issue of the magazine *Interview* is published.
"For me, the most confusing period of the whole sixties was the last sixteen months. I was taping and Polaroiding everything in sight…"[4]

1970–71

Commissioned portraits are his main activity in the 1970s and 1980s.
Rain Machine, a water installation with 3-D flowers is shown at Expo '70 in Osaka.
Begins working with video.
Major retrospective at the Pasadena Art Museum (12 May–21 June).
First monograph by Rainer Crone is published. Designs the album cover *Sticky Fingers* for the Rolling Stones.
His play, *Pork*, is staged in New York and in London.
"Business art is the step that comes after Art."[5]

1972

Begins the series of *Mao* paintings, drawings, and prints.
Death of his mother.
"I broke something today, and I realized I should break something once a week to remind me how fragile life is."[5]

1973

Appears in the film *The Driver's Seat* with Elizabeth Taylor.
Ronnie Cutrone becomes his new assistant.
"Everything is more glamorous when you do it in bed… even peeling potatoes."[5]

1974

Moves to new studio at 860 Broadway, in addition to large working spaces there is an exquisitely furnished conference and dining room. The studio is called an 'office'.
"You're better off putting all your energy into your work. Sex takes up too much time."[5]

1975

Begins the series *Ladies and Gentlemen*.
Makes the video *Fight*. Publishes *The Philosophy of Andy Warhol (From A to B and Back Again)*. Produces the musical *Man on the Moon*, which plays on Broadway.
"I'm really afraid to feel happy because it never lasts."[5]

1976

Begins both the *Skull* and *Hammer and Sickle* series .
"I never have time to think about the real Andy Warhol. I'm just so busy… not working, but busy playing, because work is play when it's something you like."[5]

1977

Begins the *Torsos* series.
He is a star at the night club Studio 54, with

Liza Minnelli, Bianca Jagger and Roy Halston.
"Muscles are great. Everybody should have at least one they can show off."[5]

1978
Begins the series *Self-Portraits with Skull, Shadows,* and *Oxidation* paintings.
"I paint pictures of myself to… I guess, yeah, to remind myself that I'm still around."[5]

1979
Begins the *Retrospective* and *Reversal* pictures. Produces the ten-part video *Fashion*, and the book *Andy Warhol's Exposures*.
"My paintings are just about entertaining people. I'm surprised it's lasted so long."[5]

1980
Begins the *Diamond Dust Shoes* and the *Joseph Beuys* portraits.
Works on the Warhol Robot project.
Publishes *POPism: The Warhol '60s*.
Jay Shriver becomes his new assistant.
Visits the Pope in Rome.
"Before going out in the evening… I always go home first to change my shirt and have dinner with my dogs. They eat what I eat."[5]

1981
Begins the series *Dollar Signs, Guns, Knives,* and *Crosses*.
"People ask me if I'm shocked that people pay thousands of dollars for one of my paintings. Well … why should I be shocked? I think it's wonderful!"[5]

1982
Trip to Hongkong and Bejing with Fred Hughes and Christopher Makos.
"Artists are never intellectuals, that's why they're artists."[5]

1983
Begins working with Jean-Michel Basquiat and Francesco Clemente.
"A good reason to be famous is so you can read all the big magazines and know everybody in all the stories."[5]

1984
New studio at 22 East 33rd Street. Begins the *Rorschach* series.
Creates a music video for The Cars.
"Switzerland is my favorite place now because it's so nothing. And everybody's rich."[5]

1985
Shows his *Invisible Sculpture* at the night club Area.
Andy Warhol's Fifteen Minutes is shown on MTV.
Produces the book *America*.
"No matter how good you are, if you are not promoted right, you won't be remembered."[5]

1986
Begins the *Self-Portraits* and the *Last Supper* series.
"I want to care, but it's so hard."[5]

1987

His last works, the *Last Supper* series, are shown at the Palazzo delle Stelline in Milan (23 Jan.–21 March).

Admitted to New York Hospital for an operation on his gall bladder. Complications arise during his recovery.

Andy Warhol dies on 22 February at the age of 58.

"I don't believe in it [death], because you're not around to know that it's happened. I can't say anything about it because I'm not prepared for it."[6]

The Andy Warhol quotes are taken from:

1 Berg, Gretchen: "Nothing to Lose." In: *Cahier du Cinema*, No.10 (May 1967), pp.38–43.

2 Swenson, G. R.: "What is Pop Art? Answers from 8 painters, part 1." In: *Artnews* 62, No.7 (November 1963), pp.24–27 and 60–65.

3 Granath, Olle, Pontus Hultén, Kaspar König, and Andy Warhol: *Andy Warhol*. Stockholm: Moderna Museet, 1968.

4 Warhol, Andy, and Pat Hackett: *POPism: The Warhol '60s*. New York/London, 1980.

5 Wrenn, Mike: *Andy Warhol in his own words*. London/New York/Sydney, 1991.

6 Warhol, Andy: *The Philosophy of Andy Warhol (From A to B and Back Again)*. New York/London, 1975.

Selected Solo Exhibitions since 1989

for exhibitions before 1989, see:
McShine, Kynaston (ed.): *Andy Warhol: A Retrospective*. New York: The Museum of Modern Art, 1989.

1989
Gian Enzo Sperone, Rome, *Andy Warhol: Disegni Drawings*, January – February.

The Museum of Modern Art, New York, *Andy Warhol: A Retrospective*, February 6 – May 2; exhibition traveled to: The Art Institute of Chicago, May 31 – August 13; Hayward Gallery, London, September 7 – November 5; Museum Ludwig, Cologne, November 20, 1989 – February 11, 1990; Palazzo Grassi, Venice, February 25 – May 27; Centre Georges Pompidou, Paris, June 21 – September 10.

Grey Art Gallery and Study Center, New York University, *Success is a Job in New York ... The Early Art and Business of Andy Warhol*, March 14 – April 9; exhibition traveled to: The Carnegie Museum of Art, Pittsburgh, June 24 – August 13; Institute of Contemporary Art, University of Pennsylvania, October 12 – November 26.

Achenbach Kunsthandel, Frankfurt a. M., *Andy Warhol: Bilder, Zeichnungen, Graphik*, April 19 – June 10.

Magidson Fine Art, New York, *Andy Warhol*, May – June.

Monash University Gallery, Clayton, Victoria, *Andy Warhol in Australia. Works from Private Collections*, June 21 – July 22.

Anthony d'Offay Gallery, London, *Andy Warhol: Portraits 1964 – 1986*, September 7 – October 10.

Art Gallery, College Park, *The Andy Warhol Athletes Portraits*, September 11 – October 22.

Grand Rapids Art Museum, *Andy Warhol: Fifteen Minutes of Fame*, September 15 – October 22; exhibition traveled to: Northern Michigan University, Marquette, October 29 – November 26; Midland Center for the Arts, December 2, 1989 – January 7, 1990; Kalamazoo Institute of Arts, January 12 – February 11; East Lansing Kresge Art Museum, Michigan State University, February 17 – April 1; Art Center of Battle Creek, April 7 – May 13; Detroit Institute of Arts, May 27 – July 22.

Vrej Baghoomian Inc., New York, *Andy Warhol: Flowers,* September 16 – October 14.

Institute of Contemporary Art, Philadelphia, *Andy Warhol: Works from 1961 – 1965*, October 18 – December 3.

Galerie Isy Brachot, Brussels, *Andy Warhol,* October 25 – December 9; exhibition traveled to: Galerie Isy Brachot, Paris, January 18 – March 3, 1990.

Gagosian Gallery, New York, *Andy Warhol: Shadow Paintings*, November.

1990
Jason McCoy Inc., New York, *Andy Warhol: Self-Portraits*, January 30 – March 1.

Fondation Cartier pour l'Art Contemporain, Jouy-en-Josas, *Andy Warhol System: Pub, Pop, Rock*, June 16 – September 9.

High Museum of Art, Atlanta, *Andy Warhol's Celebrities*, September 11, 1990 – January 6, 1991.

Galleria Gottardo, Lugano, *1975 Ladies and Gentlemen*, September 18 – November 17.

Louisiana Museum of Modern Art, Humlebæk, *Andy Warhol*, September 22, 1990 – January 6, 1991.

Hamburger Kunsthalle, *Andy Warhol and Velvet Underground*, November 30, 1990 – February 3, 1991.

1991
Mitsukoshi Ltd., Tokyo, *Andy Warhol*, January 8 – 20.

Galerie Volker Diehl, Berlin, *Andy Warhol*, April.

1992
Dia Art Foundation, Bridgehampton, N.Y., *Andy Warhol: Oxidation Paintings*, June 6 – July 29.

Tel Aviv Museum of Art, *Andy Warhol 1928 – 1987: Works from a Private Collection and The Isle of Man Co.*, August 27 – October 27.

Gagosian Gallery, New York, *Andy Warhol: Heaven and Hell Are Just One Breath Away! Late Paintings and Related Works 1984 – 1986*, November 14, 1992 – January 30, 1993.

Galerie Bruno Bischofberger, Zurich, *Andy Warhol: Works of the Sixties*, November 16, 1992 – April 3, 1993.

1993

Milwaukee Art Museum, *Andy Warhol: Works from the Permanent Collection*, February 22 – April 25. KunstHaus Wien, *Andy Warhol 1928 – 1987: Werke aus den Sammlungen José Mugrabi und einer Isle of Man Company*, February 23 – March 31.

Deichtorhallen Hamburg, *Andy Warhol: Retrospectiv*, July 2 – September 19; exhibition traveled to: Württembergischer Kunstverein, Stuttgart, November 13, 1993 – February 6, 1994.

Kunsthalle Basel, *Andy Warhol: Abstrakt*, September 19 – November 14; exhibition traveled to: MAK – Österreichisches Museum für angewandte Kunst, Vienna, December 1, 1993 – February 20, 1994; Kunsthal, Rotterdam, February 27 – May 1; Rooseum, Malmö, May 21 – July 31; IVAM Centre Julio González, Valencia, September 15 – November 27.

The Menil Collection, Houston, *Andy Warhol: Portraits*, September 24 – December 19.

Museum of Contemporary Art, Sydney, *Andy Warhol: Portraits of the Seventies and Eighties*, November 21, 1993 – March 6, 1994; exhibition traveled to: Anthony d'Offay Gallery, London, April 22 – May 28; Sala de Exposiciones Rekalde, Bilbao, July 5 – August 28, Galerie Max Hetzler, Berlin, October 7 – November 4; Achenbach Kunsthandel, Düsseldorf, November 25 – December 22.

1994

Fort Lauderdale Museum of Art, *Andy Warhol: A Retrospective*, January 13 – March 13.

Galerie Thaddaeus Ropac, Paris, *Warhol: Drawings 1952 – 1986*, May 28 – July 16; exhibition traveled to: Galerie Thaddaeus Ropac, Salzburg, July 26 – August 31.

Galerie Volker Diehl, Berlin, *Andy Warhol: Flowers*, June 10 – July 31.

The Ho-Am Art Gallery, Seoul, *Andy Warhol: Pop Art's Superstar*, August 20 – October 9.

Dia Center for the Arts, New York, *Andy Warhol: The Last Supper Paintings*, September 16, 1994 – June 25, 1995.

Taipei Fine Arts Museum, *Andy Warhol 1928 – 1987: A Private Collection*, October 8 – November 20.

Edition Schellmann, Cologne, *Andy Warhol Art from Art: Unique screenprints, drawings, and collages 1963 – 86*, April 29 – September 30; exhibition traveled to: Documenta & Museum Fridericianum, Kassel, November 11, 1994 – February 15, 1995.

Anthony d'Offay Gallery, London, *Andy Warhol: Gold, Silver & Other Early Drawings*, December 6, 1994 – January 26, 1995.

1995

Robert Miller Gallery, New York, *Andy Warhol: Nudes*, May 2 – June 17.

Galerie Daniel Blau, Munich, *Andy Warhol: Bilder*, May 12 – June 30.

Musée Olympique, Lausanne, *Andy Warhol: Fondation Antonio Mazzotta*, May 25 – October 1.

Fondation de l'Hermitage, Lausanne, *Andy Warhol: Collection José Mugrabi*, May 25 – October 1.

The Vancouver Art Gallery, *Andy Warhol: Images*, June 22 – October 1.

Kunstmuseum Luzern, *Andy Warhol: Paintings 1960 – 1986*, July 9 – September 24.

Susan Sheehan Gallery, New York, *Andy Warhol: Early Drawings*, September 5 – October 14.

Fondazione Antonio Mazzotta, Milan, *Andy Warhol: dalla Collezione José Mugrabi con le opere grafiche della Fondazione Antonio Mazzotta*, October 22, 1995 – February 11, 1996.

Anthoy d'Offay Gallery, London, *Andy Warhol. Vanitas: Skulls and Self-Portraits 1976 – 1986*, November 28, 1995 – January 27, 1996.

1996

Museum of Contemporary Art, Tokyo, *Andy Warhol. 1956 – 86: Mirror of His Time*, April 17 – June 23; exhibition traveled to: Fukuoka Art Museum, July 10 – August 25; Hyogo Prefectural Museum of Modern Art, Kobe, September 14 – November 17.

Susan Sheehan Gallery, New York, *Andy Warhol 1955 – 1975: Twenty Years of Pop*, April 30 – June 29.

Maschio Angioino, Naples, *Warhol: Viaggio in Italia*, July 20 – November 2; exhibition traveled to: Chiostro del Bramante, Rome, April 9 – June 29, 1997.

Wilhelm-Hack Museum, Ludwigshafen, *Andy Warhol: Sammlung José Mugrabi,* September 15, 1996 – January 6, 1997.

Fondació Joan Miró, Barcelona, *Andy Warhol 1960 – 1986,* September 19 – December 1.

Gagosian Gallery, New York, *Andy Warhol: Rorschach Paintings*, September 21 – October 19.

Galerie Jérôme de Noirmont, Paris, *Andy Warhol*, November 29, 1996 – January 25, 1997.

1997

Jablonka Galerie, Cologne, *Eggs by Andy Warhol*, March 7 – April 19.

James Danziger Gallery, New York, *Andy Warhol: Toy Paintings*, April 16 – May 30.

Sabine Wachters, Brussels, *Andy Warhol: Paintings*, April 23 – June 14.

Tony Shafrazi Gallery, New York, *Andy Warhol. Thirty Are Better Than One*, May 3 – June 14.

Galerie Thaddaeus Ropac, Paris, *Andy Warhol: Heads (after Picasso)*, May 3 – July 14.

Helsingin Taidehalli, Helsinki, *Andy Warhol: Samlingen José Mugrabi*, August 23 – November 16.

Anthony d'Offay Gallery, London, *Andy Warhol: Gun Paintings*, September 1997 – March 1998.

Susan Sheehan Gallery, New York, *Andy Warhol: Paintings, Drawings, Prints*, October 21 – December 13.

Gagosian Gallery, New York, *Andy Warhol: $,* November 1 – 29.

Whitney Museum of American Art, New York, *The Warhol Look. Glamour Style Fashion*, November 8, 1997 – January 18, 1998; exhibition traveled to: Art Gallery of Ontario, Toronto, February 16 – May 3; Barbican Art Gallery, London, May 28 – August 16; Musée de la Mode, Marseille, September – November; Museum of Contemporary Art, Sydney, December 1998 – March 1999; The Andy Warhol Museum, Pittsburgh, June 4 – September 3, 2000.

The Irish Museum of Modern Art, Dublin, *After the Party. Andy Warhol Works 1956 – 1986*, November 20, 1997 – March 22, 1998.

1998
The Art Gallery at the University of Maryland, *Reframing Andy Warhol: Constructing American Myths, Heroes, and Cultural Icons*, February 5 – April 18.

National Museum, Warsaw, *Andy Warhol: Works from a Private Collection of José Mugrabi*, March 6 – May 3; exhibition traveled to: National Museum, Cracow, May 19 – June 30

Galerie Daniel Blau, Munich, *Andy Warhol: Oxidation Paintings*, March 6 – May 13.

Jablonka Galerie, Cologne, *Andy Warhol: 'Knives,'* March 13 – April 18.

Brooke Alexander, New York, *Andy Warhol: Portrait Drawings*, April 3 – June 13.

Galerie Burkhard H. Eikelmann, Essen, *Andy Warhol: Unikate auf Leinwand und Papier*, April 25 – May 30.

Richard Gray Gallery, New York, *Andy Warhol (After de Chirico)*, May 5 – 30.

Kunstmuseum Basel, *Andy Warhol: Zeichnungen 1942 – 1987*, May 5 – July 19; exhibition traveled to: Museum Schloss Moyland, Kleve, August 1 – September 20; Kunsthalle Tübingen, October 3 – November 29; Neue Galerie der Stadt Linz, December 12, 1998 – February 28, 1999; Walker Art Center, Minneapolis, August 7 – November 28; The Andy Warhol Museum, Pittsburgh, March 27 – Juni 13, 2000.

Bayerische Staatsgemäldesammlungen / Staatsgalerie moderner Kunst, Munich, *Andy Warhol: The Last Supper*, May 27 – September 27.

Bruce R. Lewin Gallery, New York, *Andy Warhol's Individual Dollar Sign and Screenprints*, September 8 – 26.

Kunstmuseum Wolfsburg, *Andy Warhol: A Factory*, October 3, 1998 – January 10, 1999; exhibition traveled to: Kunsthalle Wien, February 5 – May 2; Société des Expositions du Palais des Beaux-Arts, Brussels, June 1 – September 19; Guggenheim Museum, Bilbao, October 19, 1999 – January 16, 2000.

Waddington Galleries, London, *Andy Warhol (After de Chirico)*, October 14 – November 14.

Paul Kasmin Gallery, New York, *Andy Warhol: Studio Still Lifes*, October 14 – November 18.

Gagosian Gallery, New York, *Andy Warhol: Camouflage*, November 7, 1998 – January 9, 1999.

Richard Gray Gallery, Chicago, *Andy Warhol: Gun Paintings*, November 20 – December 19.

Susan Sheehan Gallery, New York, *Andy Warhol: Drawings*, December 1, 1998 – January 16, 1999.

Dia Center for the Arts, New York, *Andy Warhol: Shadows*, December 4, 1998 – June 13, 1999.

1999
Anthony d'Offay Gallery, London, *Andy Warhol: Paintings and Sculpture*, January 29 – March 11.

Diözesanmuseum, Cologne, *Andy Warhol: Crosses*, February 19 – May 24.

The Andy Warhol Museum, Pittsburgh, *Watching From the Wings: Andy Warhol and Dance*, February 27 – May 23.

Galerie Thaddeaus Ropac, Paris, *Andy Warhol: The Statue of Liberty*, March 6 – April 17.

Gagosian Gallery, New York, *Andy Warhol: Philip's Skull*, April 6 – May 22.

Galerie Daniel Blau, Munich, *Andy Warhol: GE Paintings*, April 15 – June 30.

Galerie Sabine Knust, Munich, *Andy Warhol: Flower Drawings 1974*, April 15 – June 30.

Hamburger Kunsthalle, *Andy Warhol: Photography*, May 13 – August 22; exhibition traveled to: The Andy Warhol Museum, Pittsburgh, Penn., November 6, 1999 – February 15, 2000.

Gagosian Gallery, New York, *Andy Warhol: Diamond Dust Shoes*, September 23 – October 30.

Wadsworth Atheneum, Hartford, *About Face: Andy Warhol Portraits*, September 23, 1999 – January 30, 2000; exhibition traveled to: Miami Art Museum, March 24 – June 4.

Richard Gray Gallery, Chicago, *Andy Warhol: Selected Late Paintings*, November 6 – December 11.

2000
The Museum of Art, Kochi, *Andy Warhol: From Collection of Mugrabi*, February 6 – March 26; exhibition traveled to: The Bunkamura Museum of Art, Tokyo, April 1 – May 21; Daimaru Museum, Umeda-Osaka, Osaka, May 24 – June 11; Hiroshima City Museum of Contemporary Art, June 17 – July 30; Kawamura Memorial Museum of Art, Sakura,

August 5 – October 1; Nagoya City Art Museum, October 7 – December 17; Niigata City Art Museum, January 4, 2001 – February 12.

Susan Sheehan Gallery, New York, *Andy Warhol and Cecil Beaton*, March 2 – May 20.

C & M Arts, New York, *Women of Warhol: Marilyn, Liz & Jackie*, April 7 – June 3.

Louisiana Museum of Modern Art, Humlebæk, *Andy Warhol and His World*, April 14 – July 30.

Jablonka Galerie, Cologne, *Andy Warhol: ,Headshots' Portraits Drawings of the 50's Paintings of the 70's and 80's*, May 5 – June 24.

Gagosian Gallery, New York, *Andy Warhol: Diamond Dust Shadow Paintings*, May 6 – June 10.

Palais Bénédictine, Fécamp, *Andy Warhol: POP' star*, June 24 – September 24.

211

Selected Bibliography since 1989

for bibliography before 1989, see:
McShine, Kynaston (ed.): *Andy Warhol: A Retrospective*. New York: The Museum of Modern Art, 1989.

Andy Warhol. New York: Magidson Fine Art, 1989.

Andy Warhol in Australia. Works from Private Collections. Clayton: Monash University Gallery, 1989.

Andy Warhol: Fifteen Minutes of Fame. Detroit: Detroit Institute of Arts, 1989.

Andy Warhol. Brussels: Isy Brachot Gallery, 1989.

Andy Warhol: Shadow Paintings. New York: Gagosian Gallery, 1989.

Bockris, Victor: *Warhol*. London: Frederick Muller, 1989.

Bourdon, David: *Warhol*. New York: Harry N. Abrams, Inc., 1989.

De Salvo, Donna M. (ed.): *Success is a Job in New York... The Early Art and Business of Andy Warhol*. New York: Grey Art Gallery & Study Center / Pittsburgh: The Carnegie Museum of Art, 1989.

Finkelstein, Nat: *Andy Warhol: Oh this is fabulous. The silver age at the Factory 1964–1967*. Rotterdam: Bébert Editions, 1989.

Garrels, Gary (ed.): *The Work of Andy Warhol*. Dia Art Foundation, Discussions in Contemporary Culture, no. 3. Seattle: Bay Press, 1989.

Guiles, Fred Lawrence: *Loner at the Ball—The Life of Andy Warhol*. London: Bantam Press, Transworld Publishers Ltd., 1989.

Hackett, Pat (ed.): *The Andy Warhol Diaries*. New York: Warner Books, 1989.

Honnef, Klaus: *Andy Warhol 1928–1987. Kunst als Kommerz*. Cologne: Benedikt Taschen Verlag, 1989.

McShine, Kynaston (ed.): *Andy Warhol: A Retrospective*. New York: The Museum of Modern Art, 1989.

O'Pray, Michael (ed.): *Andy Warhol: Film Factory*. London: British Film Institute, 1989.

Wünsche, Hermann (ed.): *Warhol Made in Germany*. Bonn / New York: Galerie Wünsche, 1989.

Andy Warhol. Humlebæk: Louisiana Museum of Modern Art, 1990.

Andy Warhol: Self-Portraits. New York: Jason McCoy, Inc., 1990.

Andy Warhol System: Pub, Pop, Rock. Jouy-en-Josas: La Fondation Cartier pour l'Art Contemporain, 1990.

Bastian, Heiner (ed.): *Andy Warhol: Silkscreens from the Sixties*. Munich: Schirmer / Mosel, 1990.

Colacello, Bob: *Holy Terror: Andy Warhol Close Up*. New York: Harper Collins Publishers, 1990.

Obalk, Hector: *Andy Warhol n'est pas un grand artiste*. Paris: Editions Aubier, 1990.

Patocchi, Luca (ed.): *1975 Ladies and Gentlemen*. Lugano: Galleria Gottardo, 1990.

Shirakura, Yoshihiko (ed.): *Andy Warhol. Shinchosha's Super Artists*. Tokyo: Ryoichi Sato, Shinchosha Co. Ltd, 1990.

Andy Warhol. Tokyo: Mitsukoshi Ltd., 1991.

Shanes, Eric: *Warhol: The Masterworks*. London: Studio Editions, 1991.

Wrenn, Mike: *Andy Warhol in his own words*. London / New York / Sydney: Omnibus Press, 1991.

Andy Warhol: Heaven and Hell Are Just One Breath Away! Late Paintings and Related Works, 1984–1986. New York: Gagosian Gallery and Rizzoli International Publications, 1992.

Fischer, Yona, and Dorit Yifat (eds.): *Andy Warhol 1928–1987: Works from a Private Collection and The Isle of Man Co*. Tel Aviv: Tel Aviv Museum of Art, 1992.

Inboden, Gudrun: *Andy Warhol: White Disaster I, 1963*. Stuttgart: Edition Cantz, 1992.

Sabin, Stefana: *Andy Warhol: Mit Selbstzeugnissen und Bilddokumenten*. Hamburg: Rowohlt, 1992.

Andy Warhol. Madrid: Galería el Coleccionista, 1993

Andy Warhol: Portraits of the Seventies and Eighties. London: Thames & Hudson and Anthony d'Offay Gallery, 1993.

Baal-Teshuva, Jacob (ed.): *Andy Warhol 1928–1987: Werke aus den Sammlungen José Mugrabi und einer Isle of Man Company*. Wien: KunstHaus, 1993.

Felix, Zdenek (ed.): *Andy Warhol – Retrospektiv*. Hamburg: Deichtorhallen, 1993.

Kellein, Thomas (ed.): *Andy Warhol: Abstrakt.* Basle: Kunsthalle, 1993.

Katz, Jonathan: *Andy Warhol.* New York: Rizzoli Art Series, 1993.

Romain, Lothar: *Andy Warhol.* Munich: Bruckmann, 1993.

Yau, John: *In the Realm of Appearances: The Art of Andy Warhol.* Hopewell, NJ: The Ecco Press, 1993.

Yonekura, Mamoru: *Andy Warhol.* Tokyo: Kodansha Ltd., 1993.

Andy Warhol: Flowers. Berlin: Galerie Volker Diehl/New York: Stellan Holm, Inc., 1994.

Andy Warhol: Pop Art's Superstar. Seoul: The Ho-Am Art Museum, 1994.

Andy Warhol: The Last Supper Paintings. New York: Dia Center for The Arts, 1994.

Alexander, Paul: *Death and Disaster: The Rise of the Warhol Empire and the Race for Andy's Millions.* New York: Villard Books, 1994.

Ping, Lin (ed.): *Andy Warhol 1928–1987: A Private Collection.* Taipei: Taipei Fine Arts Museum, 1994.

Schellmann, Jörg (ed.): *Andy Warhol Art from Art.* Cologne: Edition Schellmann, 1994.

The Andy Warhol Foundation for the Visual Arts, Inc. (ed.): *Angels, Angels, Angels / Andy Warhol.* New York/Boston/Toronto/London: Bulfinch Press Book, Little, Brown and Company, 1994.

The Andy Warhol Museum, Pittsburgh (ed.): *The Andy Warhol Museum.* New York: Distributed Art Publishers/Stuttgart: Cantz Publishers, 1994.

Andy Warhol: Collection José Mugrabi. Lausanne: Fondation de l'Hermitage, 1995.

Andy Warhol. Vanitas: Skulls and Self-Portraits 1976–1986. London: Anthony d'Offay Gallery, 1995.

Cheim, John (ed.): *Andy Warhol Nudes.* New York: Robert Miller Gallery, 1995.

Copplestone, Trewin: *The Life and Works of Andy Warhol.* Bristol: Parragon Book Service Limited, 1995.

Fondazione Antonio Mazzotta (ed.): *Andy Warhol: dalla Collezione José Mugrabi con le opere grafiche della Fondazione Antonio Mazzotta.* Milan: Edizioni Gabriele Mazzotta, 1995.

International Olympic Committee (ed.): *Andy Warhol: Fondation Antonio Mazzotta.* Lausanne: Musée Olympique, 1995.

Lüthy, Michael: *Andy Warhol. Thirty Are Better Than One.* Frankfurt a. M.: Insel Verlag, 1995.

Schwander, Martin (ed.): *Andy Warhol: Paintings 1960–1986.* Luzern: Kunstmuseum, 1995.

Thom, Ian M.: *Andy Warhol Images.* Vancouver: The Vancouver Art Gallery, 1995.

Andy Warhol 1960–1986. Barcelona: Fondació Joan Miró, 1996.

Andy Warhol: Rorschach Paintings. New York: Gagosian Gallery, 1996.

Andy Warhol. Paris: Galerie Jérôme de Noirmont, 1996.

Warhol: Viaggio in Italia. Naples: Maschio Angioino, 1996 (Rome: Chiostro del Bramante, 1997).

Bastian, Heiner (ed.): *Sammlung Marx. Andy Warhol. Frühe Zeichnungen.* Munich: Schirmer/Mosel, 1996.

Cappa Legora, Cristina: *Andy Warhol. Eine unglaubliche Geschichte nicht nur für Kinder.* Milan: Edizioni Gabriele Mazzotta, 1996.
Doyle, Jennifer, Jonathan Flatley, and José Esteban-Muñoz (eds.): *Pop Out: Queer Warhol.* Durham/London: Duke University Press, 1996.

Gassen, Richard W.(ed.): *Andy Warhol: Sammlung José Mugrabi.* Ludwigshafen: Wilhelm-Haack Museum, 1996.

O'Connor, John, and Benjamin Liu (eds.): *Unseen Warhol.* New York: Rizzoli International Publications, Inc, 1996.

Shioda, Junichi, et. al. (eds.): *Andy Warhol. 1956–86: Mirror of His Time.* Pittsburgh: The Andy Warhol Museum/Tokyo: Asahi Shimbun, 1996.

After the Party. Andy Warhol Works 1956–1986. Dublin: The Irish Museum of Modern Art, 1997.

Andy Warhol: Heads (after Picasso). Paris/Salzburg: Galerie Thaddaeus Ropac, 1997.

Andy Warhol: Thirty Are Better Than One. New York: Tony Shafrazy Gallery, 1997.

Andy Warhol: Samlingen José Mugrabi. Helsinki: Helsingin Taidchalli, 1997.

Andy Warhol: $. New York: Gagosian Gallery, 1997.

Feldman, Frayda, and Jörg Schellmann (eds.): *Andy Warhol Prints: A Catalogue Raisonné 1962–1987.* New York: Distributed Art Publishers in Association with Ronald Feldman Fine Arts, Inc./Edition Schellmann and The Andy Warhol Foundation for the Visual Arts, Inc., 1997.

Faerna, José María (ed.): *Warhol. Great Modern Masters.* New York: Camco/Abrams, 1997.

Francis, Mark, and Margery King (eds.): *The Warhol Look. Glamour Style Fashion.* New York: Whitney Museum of American Art, 1997.

Jablonka, Rafael (ed.): *Eggs by Andy Warhol.* Cologne: Jablonka Galerie, 1997.

MacCabe, Colin, Mark Francis, and Peter Wollen (eds.): *Who is Andy Warhol?* Great Britain: British Film Institute/Pittsburgh: The Andy Warhol Museum, 1997.

Pratt, Alan R. (ed.): *The Critical Response to Andy Warhol*. Westport, CT: Greenwood Press, 1997.

Slotover, Matthew (ed.): *All Tomorrow's Parties. Billy Name's Photographs of Andy Warhol's Factory*. London: Frieze/New York: D.A.P., 1997.

Trétiack, Philippe: *Warhol´s America*. London: Thames and Hudson, 1997.

Wolf, Reva: *Andy Warhol, Poetry and Gossip in the 1960s*. Chicago/London: The University of Chicago Press, 1997.

Andy Warhol: A Factory. Wolfsburg: Kunstmuseum, 1998.

Andy Warhol Studio Still Lifes. New York: Paul Kasmin Gallery, 1998.

Andy Warhol (After de Chirico). London: Waddington Galleries, 1998.

Andy Warhol: Zeichnungen 1942–1987. Basel: Kunstmuseum/Pittsburgh: The Andy Warhol Museum, 1998.

Andy Warhol: Shadows. New York: Dia Center for the Arts, 1998.

Andy Warhol: Portrait Drawings. New York: Brooke Alexander, 1998.

Dillenberger, Jane Daggett: *The Religious Art of Andy Warhol*. New York: Continuum, 1998.

Folga-Januszewska, Dorota (ed.): *Andy Warhol: Works from a Private Collection of José Mugrabi*. Warsaw: National Museum, 1998.

Grossman, Wendy (ed.): *Reframing Andy Warhol: Constructing American Myths, Heroes, and Cultural Icons*. Maryland: The Art Gallery at the University of Maryland, 1998.

Jablonka, Rafael (ed.): *Andy Warhol: 'Knives.'* Cologne: Jablonka Galerie, 1998.

Schulz-Hoffmann, Carla (ed.): *Andy Warhol. The Last Supper*. Bayerische Staatsgemäldesamm-

lung/Staatsgalerie moderner Kunst München, 1998.

Wingate, Ealan (ed.): *Andy Warhol: Camouflage*. New York: Gagosian Gallery, 1998.

Andy Warhol: Photography. Hamburg: Hamburger Kunsthalle/Pittsburgh: The Andy Warhol Museum, 1999.

Andy Warhol: Diamond Dust Shoes. New York: Gagosian Gallery, 1999.

Andy Warhol: Crosses. Cologne: Diözesanmuseum, 1999.

Andy Warhol: The Statue of Liberty. Paris: Galerie Thaddaeus Ropac, 1999.

Andy Warhol: Philip's Skull. New York: Gagosian Gallery, 1999.

Andy Warhol: GE Paintings. Munich: Galerie Daniel Blau, 1999.

Baume, Nicholas (ed.): *About Face: Andy Warhol Portraits*. Hartford: Wadsworth Atheneum/Pittsburgh: The Andy Warhol Museum, 1999.

Frei, Georg (ed.): *Andy Warhol: Hammer and Sickle*. Zurich: Thomas Ammann Fine Art AG, 1999.

Knust, Sabine (ed.): *Andy Warhol: Flower Drawings 1974*. Munich: Galerie Sabine Knust/Maximilian Verlag, 1999.

Andy Warhol and Cecil Beaton. New York: Susan Sheehan Gallery, 2000.

Andy Warhol and His World. Humlebæk: Louisiana Museum of Modern Art, 2000.

Andy Warhol: Diamond Dust Shadow Paintings. New York: Gagosian Gallery, 2000.

Women of Warhol: Marilyn, Liz & Jackie. New York: C & M Arts, 2000.

Bianchi, Paolo, and Christoph Doswald: *Andy Warhol GegenSpieler Joseph Beuys*. Frankfurt a. M.: Fischer Taschenbuch Verlag, 2000

Heymer, Kay (ed.): *Andy Warhol: 'Headshots' Portraits, Drawings of the 50's, Paintings of the 70's and 80's*. Cologne: Jablonka Galerie, 2000.

Kijima, Shunsuke, Nobuyuki Hiromoto, and Kenji Nishihara (eds.): *Andy Warhol: From the Collection of Mugrabi*. Kochi: The Museum of Modern Art, 2000.

Photo Credits

216

Exhibition
Georg Frei (Guest Curator)

Exhibition realisation
Verena Formanek
Bruno Guthauser
Ben Ludwig

Fondation Beyeler
Baselstr. 101
CH–4125 Riehen/Basel
Phone: 0041 (0) 61 645 97 00
Fax: 0041 (0) 61 645 97 19
Internet: www.beyeler.com
e-Mail: fondation@beyeler.com

This book is published on the occasion of the
exhibition *Andy Warhol – Series and Singles*
at the Fondation Beyeler, Riehen/Basle
(Sept. 17–Dec. 31, 2000)

Edited by
Fondation Beyeler

Conception
Georg Frei

Editorial staff
Delia Ciuha
Andrew Masullo
Christa Meienberg
Tanja Narr
Karin Sutter
Luis Villamuera
Viola Weigel

Editing
ed_it! Donga & Tekampe

Design
Birgit Haermeyer

Production
Peter Dreesen, Marcus Muraro

Lithography
Media Cologne, Cologne

Printed by
Rasch, Bramsche

Bound by
Bramscher Buchbinder Betriebe

Translations into English:
Maureen Roycroft Sommer

The English language essays by Peter Gidal and
Edward Sanders are unrevised original versions.

Library of Congress Card Number: 00–111586

Printed in Germany
Distributed by Yale University Press
ISBN 0300–08994–5